PEREGRINE BOOKS

THE ENGLISHNESS OF ENGLISH ART

No one is better qualified than Professor Pevsner to undertake this discussion of national characteristics in English art. Born and educated on the Continent he has the unbiased eye of the foreigner, and having lived and worked in England for over thirty years he possesses an unrivalled knowledge of his subject.

To draw the contours of this 'geography of art' it is necessary, says the author, to look at matters in terms of 'polarities', since it is only in examining the seeming contradictions of art that we can hope to discover what is specifically English in each distinctive style.

Two such polarities are the decorated and the perpendicular styles in architecture – the one all undulating curves and playful spatial rhythms, the other relying entirely on the straight line for its effect of uninterrupted spatial clarity. And yet, in that both are anti-corporeal, denying volume any part in the performance, both are unmistakably English.

This well-illustrated survey of English visual and functional art was described, in its original form, by the *Journal of Education* as being 'far and away the best of the Reith Lectures so far'.

Sir Nikolaus Pevsner, who was born in 1902 and educated at Leipzig, is Emeritus Professor of History of Art at Birkbeck College, University of London, and from 1949 to 1955 was Slade Professor of Fine Art and a Fellow of St John's College, Cambridge. He has been connected with numerous universities, including Leipzig and Munich.

From its inception until 1977 he edited the *Pelican History of Art and Architecture* and has written 46 volumes of *The Buildings of England* by counties. He is reckoned among the most learned and stimulating writers on art alive. His book on *Italian Painting From the End of the Renaissance to the End of Baroque* is considered a standard work. Among his other publications are *High Victorian Design*, *Sources of Modern Art*, *Pioneers of Modern Design* (Penguin) and he is co-author of the *Penguin Dictionary of Architecture*. His latest books are *Some Architectural Writers of the Nineteenth Century* (1973) and *A History of Building Types* (1976) which won the Wolfson Literary Award.

Sir Nikolaus is a widower and has three children and nine grandchildren. He lives in Hampstead.

D1053453

Nikolaus Pevsner

THE ENGLISHNESS OF ENGLISH ART

an expanded and annotated version of the
Reith Lectures broadcast in October
and November 1955

Penguin Books

Penguin Books Ltd, Harmondsworth, Middlesex, England
Penguin Books, 625 Madison Avenue,
New York, New York 10022, U.S.A.
Penguin Books Australia Ltd, Ringwood,
Victoria, Australia
Penguin Books Canada Ltd, 2801 John Street,
Markham, Ontario, Canada L3R 1B4
Penguin Books (N.Z.) Ltd, 182–190 Wairau Road,
Auckland 10, New Zealand

First published in book form by the Architectural Press 1956
Published in Peregrine Books 1964
Reprinted 1976, 1978

Made and printed in Great Britain by Fletcher & Son Ltd, Norwich
Set in Monotype Imprint

For H. de C.

CONTENTS

FOREWORD

Whether a book on the Englishness of English art or indeed the national characteristics of the art of any nation is a justifiable and a worth-while undertaking will be discussed in the introductory chapter following this Foreword. Here it is my sole intention to answer the question which might well be asked, why I should have set myself up as a judge of English qualities in English art, being neither English-born nor English-bred, having entered England only at the age of twenty-eight and lived in the country not much longer than thirty years. Thirty years is admittedly not a long time to learn to understand a country. On the other hand, my antecedents might be accepted as specially useful for the task. For one thing the very fact of having come into a country with fresh eyes at some stage, and then of having settled down gradually to become part of it, may constitute a great advantage. As for my own professional career I had worked on Saxon Baroque architecture at Leipzig and Dresden, and then on Italian Baroque painting, before I first reached England in 1930. The contrast was complete, and it was, against all expectations, agreeable too. Stimulated by this accidental demonstration of opposite national qualities in art, I began to collect material on the subject of this book. By 1941 and 1942, for a course of lectures at Birkbeck College, the staff of which

I then joined, and to which I still happily belong, all this collected material had to take some shape. Immediately after the war I went back to it and this time with a view to making a book of it. It was then that I came across the only existing book on the subject, a very remarkable book, by the Viennese art historian, Professor Dagobert Frey. It is called *Englisches Wesen in der bildenden Kunst* (*The English Character as reflected in English Art*) and was published in the middle of the war, in 1942. Yet it is absolutely free from any hostile remarks, let alone any Nazi bias – a completely objective and indeed appreciative book, written with great acumen, sensitivity, and a remarkably wide knowledge. And it confirmed often to an amazing and almost embarrassing degree my views, the criteria I had worked out, even the examples I had chosen to illustrate them, though Professor Frey runs through the manifestations of the English character in English art chronologically, from epoch to epoch, whereas I shall in my much smaller book disregard chronological order – because it is a historical rather than geographical system of arrangement – and replace it by an order of categories. There are eight chapters in all. The first serves as an introduction. Four have as their centre the figure of one especially familiar English painter – Hogarth, Reynolds, Blake, Constable – the middle chapter proceeds from the most English of architectural styles, the Perpendicular. The last two chapters deal with the Picturesque and principles of planning and, from that platform, with attempts to arrive at valid conclusions.

The result of my particular upbringing in Germany ought to have been a rigidly categorizing book. This book, however, is not as systematic as I would no doubt have made it fifteen years ago and as critics might wish it to be. The reason is in all sincerity, as far as I can now see, that English art in nearly all ages escapes the system. Often it even escapes the accurate dating by style which is the art historian's ambition. The plan for a book must be adapted to its subject. After several attempts I found that to bring out the English qualities in English art a

more compartmented treatment was useless. This verdict may of course be due to a weakness of my unphilosophical mind, or a lack of subtleness in discovering categories or applying them. Or it may be the result of a fear of losing in truth and in richness what could be gained in order and in lucidity. To decide between these possibilities must be left to the reader.

Finally a few words of thanks: to Donald Boyd for much valuable advice, to the B.B.C. Publications Department for the loan of many blocks, to the B.B.C. Television authorities for sympathetic treatment, to Dr H. Heimann for finding suitable illustrations and telling comparisons, to Miss B. Hart and Miss P. Entract of the B.B.C. for help on other illustrations, to Mr J. H. Wedgwood for the loan of a precious catalogue of Messrs Josiah Wedgwood & Sons, and to Raymond Philp and the Architectural Press for piloting the book through the various stages of production at racing speed.

London, December 1955

Foreword to the Peregrine Edition

It has been gratifying to see that no changes worth mentioning had to be made between 1955 and 1963. Wording has been adjusted here and there, footnotes have been added, references to topical events especially in architecture have been brought up to date, and that is about all.

ACKNOWLEDGEMENTS

The author and publisher acknowledge with thanks permission to reproduce photographs as follows:

55a, 86, 87, by gracious permission of Her Majesty the Queen; 1, 84, the Trustees of the Tate Gallery, London; 4 a and b, 20, 82, 83, the Trustees of the National Gallery, London; 9, Mr Dyson Perrins; 2, 10a, 14a, 64, 67, 71b, 73a, 79, 81, the Trustees of the British Museum; 10b, 27, 78, the Trustees of Sir John Soane's Museum; 14b, Mr John R. Freeman; 12, 85a, Mr C. J. P. Cave; 11b, 16a, 25, 26b, 33a, 39, 40a, 48 a and b, 50, 51b, 54, 63b, National Buildings Records; 11a, 47a, 62, Mr F. H. Crossley; 8, Royal Holloway College; 7, Sir Colin Anderson; 16b, Topical Press Agency; 15a, the British Cast Iron Research Association; 15b, 89, 92, *Architectural Review*; 17, Royal Academy of Arts; 18, the Art Institute of Chicago; 19a, Dulwich College Picture Gallery; 19 b and c, 22b, the Mansell Collection; 22a, the National Gallery of Ireland; 21, the Trustees of the Wallace Collection, London; 23, the Marchioness of Crewe; 24, Mr E. S. B. Elcome; 26a, Mr F. R. Yerbury; 28, Mr G. L. Mellin; 29, Mr Tom Ingram; 30b, Walker Art Gallery, Liverpool; 31b, Mr Henry-Russell Hitchcock, author, and Duell, Soan & Pierce, New York, publishers of *In The Nature of Materials*; 32, Valentine & Sons Ltd; 36, Crown copyright, by permission of the Controller of H.M. Stationery Office; 37b, the Master and Fellows of Trinity College, Cambridge; 33b, 47c, Rev. F. Sumner; 34a, Essex Record Office; 34b, Mr Sam Lambert; 40b, 51a, 59, 60, Mr A. F. Kersting; 42, 91b, Aerofilms Ltd; 44, 47b, Mr Herbert Felton; 46, Mr J. Allan Cash; 52a, 53b, Mrs P. Bicknell; 52b, Mr A. W. Kerr; 53a, Mr W. J. Green; 56 a and b, Mr A. Gardner;

57, 61a, 68, 75a, 85b, 90a, Victoria and Albert Museum (Crown copyright); 55b, Earl Spencer; 61b, 71a, Josiah Wedgwood & Sons Ltd; 63a, Mrs E. G. Tasker; 73b, the Syndics of the Fitzwilliam Museum, Cambridge; 74, 75b, Bodleian Library, Oxford; 66, Trinity College, Dublin; 65, the Archbishop of Canterbury and the Church Commissioners (photographer: Mr Otto Fein, Warburg Institute); 72a, Courtauld Institute of Art, London University; 72b, Faber & Faber Ltd; 69, the Henry E. Huntington Library and Art Gallery, California; 70, Osterley Park House (Crown copyright); 77, Whitworth Art Gallery, Manchester; 80, Sir Kenneth Clark; 88, the Earl of Durham; 91a, Compagnie Aérienne Française; 90b, *The Times*; 92, P.–A. Reuter Photos Ltd; 93a, City Planning Office, Corporation of London; 93b, London County Council; 94, Mr F. Gibberd; 95, Stevenage Development Corporation; 96a, Mr John R. Pantlin; 96c, *Architects' Journal*.

Thanks are also expressed to the following for permission to reproduce plans:
38, Mr G. H. Cook, author of *The English Mediaeval Parish Church*, published by Phoenix House; 43 and 49, Mr A. W. Clapham, author of *English Romanesque Architecture before the Conquest*, published by Oxford University Press, and also Mr W. H. Knowles, who measured and drew the original plan for 43.

THE GEOGRAPHY OF ART

The following pages are an essay in the geography of art. Whereas the history of art is concerned with what all works of art and architecture have in common because they belong to one period, in whatever country within the same civilization they may have been made, the question asked by a geography of art is what all works of art and architecture of one people have in common, at whatever time they may have been made. That means that the subject of a geography of art is national character as it expresses itself in art.

As soon as the question is posed in this way, two objections are bound to arise. First: Is it desirable to stress a national point of view so much in appreciating works of art and architecture? Second: Is there such a thing at all as a fixed or almost fixed national character? Neither of these questions is confined to art.

Those who are against stressing nationality in art argue that in an age of such rapid communications as ours, with such an international force as science in command, with daily press and illustrated journals, with wireless and film and television keeping everyone all the time in touch with all other parts of the world, everything ought to be avoided that glorifies obsolete national divisions. It is bad enough, they argue, that nationalism has had such a come-back in the last twenty years, and that new

small national States have appeared and are appearing everywhere on the map. Therefore any approach to art or literature is better than the nationalistic. In answer to this argument it ought to be pointed out that geography of art is by no means nationalism in action, although some very intelligent and sensitive art historians have unquestionably made it appear so. In the case for instance of the particular essay on the geography of English art which is to follow, the result is not meant to be a peremptory: 'This is English, and let no Englishman try to do otherwise!' but rather the prospect of so complex a scene of seemingly opposed forms and principles, and seemingly opposed sympathies and antipathies that those ready to explore it ought to emerge with a widened and not a narrowed sense of this country's national possibilities.

The second objection to any endeavour in the geography of art is that there does not exist anything like a national character consistent over centuries. To this there is a quick, though admittedly superficial, answer. It will, however, do at this stage, even if only as an introduction to the complexity of the theme. In act three, scene five, of *Romeo and Juliet*, Juliet says: 'It was the nightingale and not the lark.' If this line is pronounced aloud first in this form and then in Italian and in German three national characters arise at once, each recognizable without hesitation: '*È l'usignol, non è la lodola*', and '*Es ist die Nachtigall und nicht die Lerche.*' The contention of the geography of art is that, as long as these three lines sound so radically different, the cultural question is begged, if one lays all the emphasis on the fact that the cover pages of illustrated magazines in nearly all European countries are shaped on the pattern of *Life* magazine, or that research developments in atomic energy and global atomic destruction run parallel in all countries which have the means to indulge in them.

A second example from language. *Costoletta* is a fine-sounding Italian word. Its English equivalent is *chop*. A mutton chop would be a *costoletta di montone*, if it were obtainable in Italian

restaurants. In its rhythm *costoletta di montone* is like a whole line of English poetry ('At a touch sweet pleasure melteth'), and rhythm is clearly the meeting-place between language and art. If the rhythms of language differ so much and so tellingly, is there not every reason to assume that the same will occur in art? There is also the difference in length – between the four syllables of *costoletta* and the one of *chop*. English is a language aspiring to the monosyllable – with its prams and perms, its bikes and its mikes, its macs and vacs, and, failing that, its Boney and its 'tele' or 'telley'. The battle-cry of the Normans at Hastings, says Wace, was '*Dex aie*', that is, God help us, that of the Saxons was '*Ut*', that is, get out.[1]* About 1830 Count Pecchio, a liberal Italian *émigré*, wrote this of the English: 'Their very language seems to be in a hurry; since it is in a great part composed of monosyllables, and two of them again are often run into one: the great quantity of monosyllables looks like . . . a kind of short-hand. The English talk little . . . that they may not lose time.'[2] Professor Walter Raleigh in a lecture at Oxford read Browning's 'All's right with the world' and added: 'It sounds like a mouth-ful of fish bones.'[3]

Now what must be stressed in these comments is that, although they seem to be identical in meaning, the explanation given by Count Pecchio would no longer be ours. The conceit of hurry, of a demon never permitting the loss of time, is far from a twentieth-century national characteristic of so exemplarily leisurely a nation. We would rather explain monosyllables (and indeed shall in this essay) by referring to understatement, the aversion against fuss, the distrust of rhetoric. Count Pecchio's Englishman of 1827 is rather the American than the Englishman of today – a notable change of character on which more will be said later.

So in this case monosyllables have remained, but their signi-ficance has changed. On the other hand, in spite of the Battle of Hastings, monosyllables are not a permanent characteristic of

* See pages 207–20 for all Notes and References.

the English language. The anxious question overheard at an important meeting the other day: 'Will he rat?' would in terms of Dr Johnson rather have been something like this: 'Do you consider it probable that he will desert our cause at this perilous stage?' And what would the same question sound like in one of Jeremy Taylor's sermons?

Here then we are on the way to recognizing not only language as expressing national character but also the impermanence of both. And it must be remembered in addition to get the full flavour of the changeableness of language that Chaucer's English today needs a translator, that Anglo-Saxon is not English at all, that the Norman court spoke French and the literary language was Latin, that the Royal Proclamation of the Provisions of Oxford in 1258 is the first major document in English, and that only in the course of the fourteenth century did English become the accepted official language of England.[4]

With language fluctuating like this, how much permanence can one expect in character, how much in art? But there is at least one among the premises of national character which has for a long time been regarded as immutable: climate. The dependence of character and history on climate can to a limited extent be traced back to Hippocrates, and certainly to Jean Bodin's *Methodus* of 1566.[5] The Abbé Dubos in 1719 was the first to apply it to art.[6] Winckelmann, more than a generation later, breathed life into it when he made use of it for his interpretation of Greek art. From him it went to Herder and then to the Romantics, especially Schlegel, and so into the nineteenth century. Animals of cold climates are grey, brown, black – tigers and parrots live in hot climates. So art too will take on a different hue in the mists of the north and under clear blue skies. May not the fact that Turner and Constable are English have something to do with that, and the fact that England could so specially sympathize with Venice and Venetian art? Similarly it is eminently telling that ever since *The Wanderer* and *The Seafarer* English poetry has shown awareness of the sea around the

island, and that hearts of oak are not only the ships, but also the mighty and ingenious roofs of the churches of England. People from the Continent find it difficult to understand that the English never accepted stone vaulting as the one and only dignified thing for a church of any pretension. A timber vault, in imitation of stone, such as exists at York Minster in the transept and in the chancel at St Albans, seems ignominious to a Frenchman. But then he has nothing like the double hammerbeam roofs of East Anglia.

So here is a whole string of facts from art and literature tentatively derived from climate. But is climate permanent? '*La fumosa Londra*' is a pun of Count Algarotti which cockneys as much as foreigners will appreciate.[7] More poetically Alfieri says the same:

> ... *nebbie spesse,*
> *Per cui tolto ai Britanni è il ciel sereno.*[8]

Less politely a contemporary of Alfieri, a German pastor in London, F. A. Wendeborn, speaks of 'the foul smoke of the coal-fires with which the city is covered eighteen hours of the twenty-four'.[9] Then there is[10] the Swiss Heinrich Meister in 1792 writing that 'to breathe the fresh air ... is a luxury ... not to be enjoyed in this noble city', and the French Jean-Paul Grosley in 1765 cursing 'the black rains' falling on London.

There is nothing surprising in all this. What is surprising is that these complaints do not seem to come into foreign visitors' letters or books at all before the middle of the eighteenth century.[11] A moist climate may be the natural climate of England and as such be permanent. It will always be conducive to mists and fogs. Tacitus refers to the 'frequent mists' of England,[12] and Nicander Nucius of Corfu in 1545–6 calls the country 'generally foggy'.[13] But black fog is moisture plus soot, and so what one complains of as climate is the combination of climate with such things as the exploitation of coal, a development of industry that calls for vast masses of coal, and, in the house, a system of heating evolved for wood fires and not yet universally

adjusted to the use of coal. Perhaps this staunch conservatism in the teeth of the greatest discomforts is English? Perhaps the early and ruthless development of mining and industry is English? All these questions will have to be answered.

For the time being it is sufficient to see that even climatic conditions are not entirely permanent in the way they affect us. If climate is no more enduring than this, how much more fickle must these qualities turn out to be on examination which we glibly call constant in our small talk.[14] No one is at a loss when it comes to enumerating the characteristics of the English today. They have been analysed and lampooned gracefully by the Czech Čapek and the Dutchman Professor Renier. It is sufficient here to remember a few: personal liberty, freedom of expression, wise compromises, that is, the two-party system not shaken by communism or fascism, the democratic system of negotiating in Parliament as well as on boards and committees, the distrust of the sweeping statement (the kind of statement on which the present book relies) and of the demagogue. Then the eminently civilized faith in honesty and fair play, the patient queueing, the wisdom in letting go in Ireland, in India, in Egypt, a strictly upheld inefficiency in the little business-things of everyday, such as the workman's job in the house, windows that will never close, and heating that will never heat, a certain comfortable wastefulness and the demonstrative conservatism of the wig in court, the gown in school and university, the obsolete-looking shop-window in St James's Street, the Steward of the Chiltern Hundreds, the Keeper of the Queen's Swans, the Portcullis Poursuivant, the City Companies, and l-s-d, and yards, and acres, and Fahrenheit. All those things have seemed as eternal as the rock of Gibraltar.

In fact they are not. Two examples must suffice as proof. Erasmus in 1517 writes in a letter from Cambridge: 'The rooms are generally so constructed that no draught can be sent through them.'[15] And Alexander Herzen, the Russian *émigré* politician and philosopher who lived in London from 1852 to 1864 says:

'Nowhere is there a crowd so dense, so terrifying as in London, yet it never in any circumstances knows how to queue.'[16]

It would be unwise to brush aside such little things as ventilation and queueing as trifles compared with the great and lasting qualities of a nation's character. For not only has Sterne in his *Sentimental Journey* said very rightly that one 'can see the precise and distinguishing marks of national characters more in these nonsensical minutiae than in the most important matters of state', but the important matters of State have also changed. Where has the Elizabethan pirate-cum-poet gone? The privateer, the man who takes the big risks and knows few scruples, and who writes accomplished sonnets in his spare time? He was a Renaissance type, and so perhaps one cannot expect him in the twentieth century. But that is just the point which has to be made at this juncture. There is the spirit of an age, and there is national character. The existence of neither can be denied, however averse one may be to generalizations. The two can act in accordance and they can interfere with one another until one seems to black out the other completely. Do the most intelligent and sophisticated actors of today play Shakespeare right, right in the sense of a sympathetic re-creation of an Elizabethan and Jacobean world? Are they keeping to the spirit of what Voltaire calls 'these monstrous farces', written by 'a genius full of force, of nature and sublimity, without a spark of good taste'?[17] Perhaps audiences have to go to Sir Donald Wolfit to see that side of Shakespeare, his exuberance and his boisterous virility, because Sir Donald was not trained in an academy, but in the rough and tumble of music hall and troupes of strolling players as they still existed until a few decades ago.[18]

Strolling Players is the title of a Hogarth picture, to which I shall refer in some detail a little later [3, p. 32], and as Shakespeare's England so Hogarth's England has gone. And with the cock-fighting and the roaring debauchery of Hogarth's England, the England of Chippendale has gone, that is, the England of high, exacting craftsmanship. About 1725 César de Saussure,

one of the most observant students of English character, wrote that the English craftsmen 'work to perfection'[19] and 'the perfection of craftwork' is still praised by Jean-Paul Grosley in 1765.[20] Nowadays few would praise English workmen as more skilful and more conscientious than those of Spain, Italy, France, or Germany, and what exists of exacting craft is confined to certain luxury or sports goods.

But gone also is the world replacing that of Chippendale, the world of the great early iron-masters and engineers and inventors, of Darby and Wilkinson, of Boulton and Watt, of Telford and Stephenson. It was a new world, the world created by the Industrial Revolution, and England was the leading nation in it, with as much impetus as she had shown in building up her empire, at the time of Hawkins and Frobisher and again at the time of Clive and Quiberon Bay and Quebec. The industrial conquest was indeed the subtler continuation of the material conquest. Wilkinson built the first major steam-engine in France, set up a cannon factory, advised at Le Creusot, and went to Prussia in 1789,[21] Telford advised on the Göta Canal in Sweden in 1808 and again in 1813,[22] Aron Manby started ironworks at Charenton in 1819 and in 1826 leased the management of Le Creusot; other English factories in France were Edwards's at Chaillot, Dixon's in Alsace,[23] and Dyer Frères at Gamaches.[24] Taylor's at Marseille built iron steamships; the first linen manufacturing in France was promoted by the English banker J. Moberley. English textile mills were erected around St Petersburg.[25] Evans's of Warsaw were supposed to be the largest manufacturers of iron implements in Europe except for John Cockerill's at Seraing in Belgium. Cockerill's father had made carding machines at Verviers. The son bought the Château of Seraing in 1817 and started machine-building, ship-building, and railway construction. He built the first Belgian railway from Brussels to Malines in 1835 and, when he died in 1840, had works in Prussia, Saxony, Silesia, and Poland.[26] The locomotives on this Belgian railway were supplied by Stephenson's.[27]

English also were the first two locomotives to reach the United States (1828), one from Foster Rastrick & Co. of Stourbridge, the other from Stephenson's. English were the locomotives on the first two German railways, Nuremberg–Fürth (1835) and Leipzig–Dresden (1837), the ones from Stephenson's, the others from Rothwell's of Bolton. The Nuremberg–Fürth line had at least one English engine-driver, whose wages exceeded those of the manager of the line.[28] English engineers were also the rule on the next German railways,[29] and on the line from Rouen to Paris, opened in 1843, which was built with English capital and mostly English labour.[30] Even in 1842, 88 out of a total of 146 railway engines in use in France were English.

Where is that restless enterprise now? Gone the way of the East India Company? And where, if that is so, are the permanent national qualities which this book stipulates? The answer is that the many cases so far assembled to prove changes in national character prove nothing final – except that the characteristics of a nation are something more complex than is usually assumed. Some of these complexities must now be mentioned to conclude this introduction.

National character does not at all moments and in all situations appear equally distinct. The spirit of a moment may reinforce national character or repel it. Moreover, as we are dealing with visual arts, the national character of one nation may be more likely to seek expression in that particular field than the national character of another nation, and the question as to how far England is a visual nation or not, or has been a visual nation and is no longer, will have to be investigated. Then, in addition to all that, it must be remembered that the visual arts, even in the most artistic nation, cannot reflect everything. There may be whole important traits to which there is no equivalent in visual terms. That is bound to make any picture of national character, in terms of art and architecture alone, one-sided.

There is, however, one way in which one can avoid at least the worst one-sidedness. In the geography of art – as indeed in the

history of art, in so far as it deals with the characteristics of consecutive styles – no simple statements must ever be expected. The Renaissance is *plastisch*, the Baroque is *malerisch*; the Germans tend to excess, the French to *esprit*. Such statements will not do. The history of styles as well as the cultural geography of nations can only be successful – that is approach truth – if it is conducted in terms of polarities, that is in pairs of apparently contradictory qualities. English art is Constable and Turner, it is the formal house and the informal, picturesque garden surrounding it. These are polarities evident at one and the same moment. Polarities appearing in two consecutive periods are: the Decorated and the Perpendicular style, Vanbrugh and Lord Burlington, Hogarth and Reynolds. What this book sets out to do is to analyse for each of these individually what is English in them, and then see how far the results really contradict each other. For instance, to anticipate what will be the object of more careful examination, Decorated is the flowing line, Perpendicular is the straight line, but both are line and not body. Constable's aim is truth to nature, Turner's world is a fantasmagoria, but both are concerned with an atmospheric view of the world, not with the firm physical objects in it, that is again not with bodies. It is true that in this Constable and Turner also represent a European and not merely an English development, but their specifically unsculptural, unplastic, cloudy, or steamy treatment is, as will be shown, English all the same.

And besides, now that these few hints have been given, it may be permitted to put the case for the defence a little more simply by offering a few examples of how surprisingly much after all does appear to be constant in the English character. Hentzner, the German tourist who came over as early as 1598, says the English are 'impatient of anything like slavery'. Misson in about 1690 says they 'eat a huge piece of roast beef on Sunday . . . and the rest cold the other days of the week'. Their idea of vegetables is 'a few cabbage leaves boiled in plain water', says Karl Philip Moritz in 1782. The English don't work too much, but believe

that 'true living consists in knowing how to live at ease', says Sorbière in 1653. Finally, the English say, 'whenever they see a handsome foreigner: he looks like an Englishman'. This piece comes from Antonio Trevisan, Venetian Ambassador to Henry VII in 1497, and is literally repeated by Hentzner a hundred years later. César de Saussure says the same: 'I don't think there is a people more prejudiced in its own favour than the British.'[31] And if one goes to Ogden Nash, one finds this:

Let us pause to consider the English
Who when they pause to consider themselves they get all reticently thrilled and tinglish,
Because every Englishman is convinced of one thing, viz:
That to be an Englishman is to belong to the most exclusive club there is.[32]

So here seems to be unanimity at last; only unfortunately, as soon as thoughts turn to art, these statements on English self-confidence collapse. None of the other nations of Europe has so abject an inferiority complex about its own aesthetic capabilities as England. Roger Fry's *Reflections on British Painting* is an example of it.[33] The following reflections on English art were written in the hope of being able to get a good deal further than Roger Fry and to obtain more valid results by analysing a wider range of works of art.

2 HOGARTH AND OBSERVED LIFE

Of the Englishness of Hogarth [1] there can be no doubt. Time and again he has gone out of his way to parade it. He went abroad only once – to France, and a fellow traveller and fellow artist says that 'wherever he went, he was sure to be dissatisfied with all he saw'.[1] He 'was often clamorously rude' in the streets. He signed a letter to the Press 'Britophil'[2] and complained in it of 'foreign interlopers'. He published his first major engraving in 1724 to castigate Raphael and Michelangelo together with Italian opera for the neglect of home-made English art, represented by the works of Shakespeare, Jonson, Dryden, Congreve, and Otway carted away on a wheelbarrow as waste-paper. And he dissuaded young artists from travelling to Italy because it would 'seduce the student from nature'.[3]

What did Hogarth call nature? He is most famous for his series of paintings and engravings such as the *Marriage à la Mode* or *The Rake's Progress*. But he began as a painter of what is called conversation-pieces, small groups of people joined together in conversation or some other action, a type of painting the English were specially fond of.[4] However, among his early paintings there is also one of a parliamentary commission sitting in judgement over a gaoler who had ill-treated prisoners in Newgate Prison. That is a kind of pictorial newspaper report

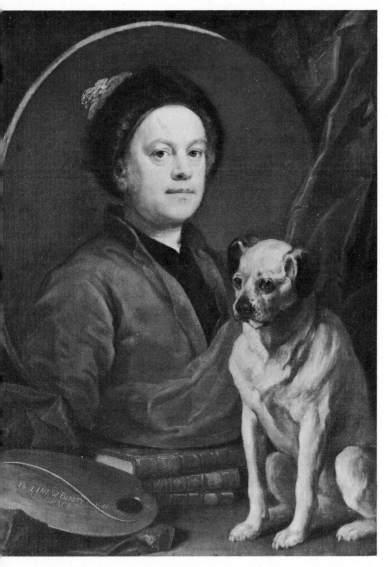

1. William Hogarth, self-portrait, 1745. Tate Gallery, London. An observant and pugnacious face. Baroque composition. The ogee line of beauty drawn on the palette.

– and a very early case of such topical illustration in paint. But Hogarth saw that he could not make enough money out of conversation-pieces without employing assistants and thereby reducing the quality of his work. So he decided to listen to 'the puffing in books about the grand style of history painting'.[5] But he did not succeed sufficiently in 'this grand business' and therefore decided to turn his 'thoughts to still a more new way of proceeding, viz. painting and Engraving modern moral Subjects, a Field unbroke up in any Country or any age'.[6] Such subjects, he wrote, would both 'entertain and Improve the mind' and at the same time be 'of public utility'.[7] And so, at the age of thirty-six he came out with *The Harlot's Progress* soon to be followed by *The Rake's Progress*, and then all the other series – *The Four Stages of Cruelty*, *Beer Street* and *Gin Lane*, *The Election Entertainment*, and so on – and also with amusing and improving single paintings and prints such as the *Roast Beef of Old England*, *Credulity*, *Superstition and Fanaticism*, the *Strolling Players in a Barn*, and so on.

Now this decision of Hogarth has several aspects specially significant in relation to his Englishness. One is his resolution to turn away from the Grand Manner and the subjects connected with it. It was a wise resolution; for England has indeed never been happy with the Grand Manner, the large, monumental, rhetorical painting of religious and mythological subjects which plays so predominant a part in the art of the Baroque, that is the seventeenth and early eighteenth centuries in Italy or France or southern Germany. As for the Baroque style in religious art Hogarth knew the reason for its absence in England. He says: 'Religion, the great promoter of this stile in other countries, in this rejected it.'[8] That is: England is a Protestant country, and there was no demand for much painting in churches. But the character of the English was against it too; that quality perhaps which shows in understatement and reticence, and certainly another and apparently more permanent quality: common sense or reason. Lord Shaftesbury, the great philosopher who died

2. Sir James Thornhill, drawing for a painting of the *Landing of George I at Greenwich*, with, in the margins, arguments against a realistic treatment and suggestions of a compromise between realism and propriety. British Museum, London.

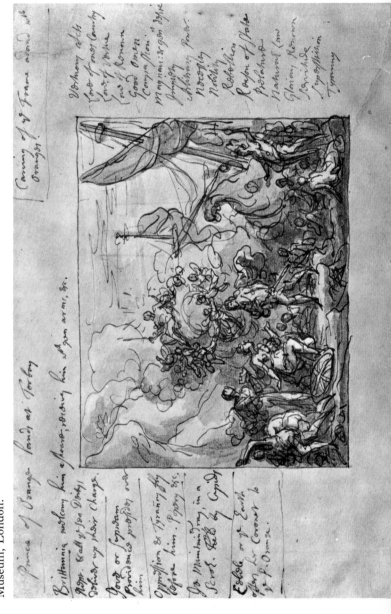

when Hogarth was sixteen, had written: 'You cannot success-
fully evoke if you don't believe.' And Hogarth's father-in-law Sir
James Thornhill, by far the most Baroque and grandest of native
English painters – as he proved, for example, in his decoration of
the Painted Hall at Greenwich – Thornhill in an extremely
interesting drawing [2] published some years ago by Professor
Wind, argued most reasonably the case for and against the
application to an event from recent history of the Grand Manner
or a truthful representation of what actually happened.[9]

The event he was going to paint was the Landing of George I
in England in 1714. For reasons which we do not know he
considered representing it truthfully as it happened. However,
he annotated his sketch with the artistic objections to such truth-
fulness:

Objections that will arise from ye plain reproduction of ye King's
landing as it was in fact. . . . First of all it was night, which to repre-
sent would be hard. . . . No ships appearing and boats make a small
figure. . . . Then who shall be shown to accompany him. . . . Of the
Royal Nobles that were there then, some of them are in disgrace
now. . . . To have dresses as they really were, difficult. . . . the King's
own dress then not graceful, not enough worthy of him to be trans-
mitted to Posterity. . . . There was a vast crowd which to represent
would be ugly, yet not to represent would be false.

All the same, he did not want to give up truth in favour of the
usual stock allegories, the Britannias, the Father Thameses, the
Tyrannic Powers Trampled Under, and so on. And so he made
the resolution to 'Take Liberty of an evening sky, make only 5
or 6 of ye Chief Nobles, enquire their dresses ye best you can
and get their faces from life, make ye King's dress as it now is
and as it should have been then, lessen ye crowd as they ought
to have been then, and bring in ye yatch that brought over ye
King and ye Barge and Guns firing.' This is indeed what his
drawing shows.

Hogarth faced with the same problem would have had no
qualms. He would unhesitatingly have chosen truth and its

everyday paraphernalia. Hogarth agreed with Dr Johnson, who once said: 'I had rather see the portrait of a dog I know than all the allegories you can show me.' This irritating remark, as so much of what the irritating Doctor said, is massively English. Fuseli, the brilliant if somewhat sensational Swiss painter who lived in England from his twenty-third year to his death and knew Reynolds as well as Blake, said there is 'little hope of Poetical painting finding encouragement in England. The People are not prepared for it. Portrait with them is everything. Their taste and feelings all go to realities.'[10] So Hogarth painted his Newgate newspaper report with the Portrait of Bembridge the gaoler looking, as Horace Walpole wrote, as if Salvator Rosa had painted Iago, and so he took his decision and started his series of 'modern moral subjects' 'to improve the mind'. Of course such a decision while being very personal to Hogarth is also what the Age of Enlightenment might have led to in any country. Yet there is also something specifically English in the cool self-consciousness of it. The way in which Hogarth reached his decision is not the way a German or an Italian artist would have speculated and proceeded. This oddly detached attitude in an artist to his own creation, this seeming lack of compulsion, is English too – but to that aspect we have to turn in a later chapter.

Meanwhile, what matters here is what Hogarth painted and how he painted it. We can discuss no more than one single painting and two episodes from one series. *Strolling Players in a Barn* [3] was published as an engraving in 1738. The scene seems at first complete chaos. The barn is crowded with people and the most heterogeneous things. Cupid, fully dressed up, is taking down a pair of stockings hanging up on a cloud. Juno is rehearsing her part, while the Goddess of Night is mending her stocking. A woman impersonating Jupiter's eagle is feeding a baby with gruel; the saucepan stands on a royal crown. And in the middle stands Chaste Diana also rehearsing. She has only a chemise on and allows you to see her very attractively rounded bosom and her plump thighs.

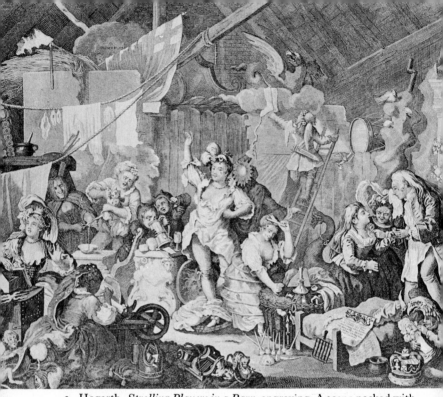

3. Hogarth, *Strolling Players in a Barn*, engraving. A scene packed with entertaining incident. The contrast between grand costume and domestic pettiness is the real theme. The enjoyment of generous curves and of half-exposed young bodies also plays its part.

Secondly the *Marriage à la Mode*. In No. 1, the marriage contract between the son of the earl and the daughter of the city merchant is signed. The two fathers are busy, one with his family tree, the other with financial documents. The young people do not care for one another. The Viscount is looking away from his fiancée and taking snuff, the girl is engrossed in a conversation with the young and ardent lawyer Counsellor Silvertongue. In the foreground a dog and a bitch are tied together by an iron chain and don't seem to enjoy it. Scene 2 is the morning after a party at the house of the young couple [4a]. The Viscount had not been present. He has come back from gaming and whoring: you see him sit in a chair, exhausted and

also depressed by his losses [4b]. A cap and ribbon hang out of his pocket, taken in the night from his female companion. Her Ladyship is *en déshabillé*, also in a chair, stretching herself idly. Playing-cards and musical instruments lie on the floor. In the adjoining dining-room a servant shuffles about respectlessly yawning, and the old steward is leaving with his ledger and a packet of unpaid bills in his hand, looking desperately worried.

And so the story goes on. Even the pictures on the walls take part. In the scene of the Levée, a picture of Ganymede appears above the Italian castrato singer, Correggio's Jupiter embracing Io above the group of the Viscountess attended by Counsellor Silvertongue. In front of this group, incidentally, a black servant-boy holds grinningly a statuette of Actaeon, that is a man with antlers on his head.

Here again, from the point of view of Hogarth's Englishness,

4a. Art used to tell a story, to preach a sermon, and to 'improve the mind'. Hogarth, Scene 2 of the *Marriage à la Mode*, *The Morning after a Party*. National Gallery, London.

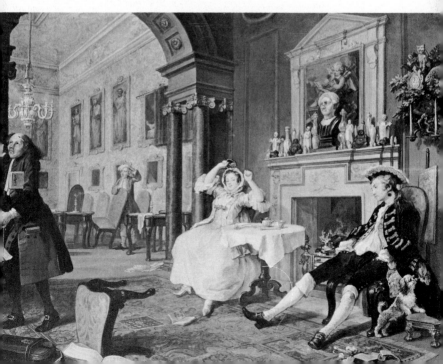

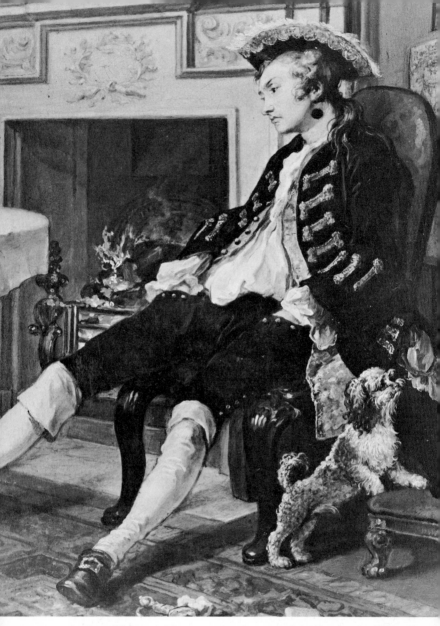

4b. In addition to the narrative interest there is also in Hogarth spirited brushwork and delight in succulent paint and undulating curves. (Detail from 4a.)

several comments must be made. Hogarth was a brilliant painter, one of the naturally most highly endowed painters of eighteenth-century England. The technique in which he tells his stories is of sumptuous fluidity, unhesitating and exuberant. But to him the story mattered more than the art.[11] The purpose of painting is not painting, but the telling of stories with all the incidents which any observant eye can discover any day. They are not embellished, on the contrary – see the *Strolling Players* – Hogarth has a mischievous pleasure in debunking. And he is never without an eye on the moral to be culled from the stories. In *Beer Street* 'all is joyous and thriving', in *Gin Lane* we see

5. Hogarth, engraving from *The Four Stages of Cruelty*. Art used to tell a story, to preach a sermon, and to 'improve the mind'.

the horrors of drunkenness – a woman, her legs covered with ulcers, dropping in her stupor her baby who crashes to its death in the area in front of the gin-shop: 'Drunk for a penny, dead drunk for twopence.' In *The Four Stages of Cruelty* [5] you have Tom Nero as a little boy torturing animals and at the end murdering a girl and being himself dissected. Of such engravings as these Hogarth wrote: 'I purtest I had rather in [my] own mind be the author of these ... prints [to] speak as a man not as an artist than [of] the seven Chatoons at hampton courtt.'[12]

A stupid statement, although Hogarth's sincerity in his efforts to help the suffering is beyond doubt – whether they were infants, or the prisoners in the indescribable gaols. What the statement does establish once again is that to Hogarth art is a medium for preaching and that the most effective sermon is the recounting of what the observant eye sees around. Both are English attitudes. The first is naturally entirely post-medieval; for in the Middle Ages most art was there to preach anyway; the second is eternally English. So the further examples of preaching by means of painting which can be referred to will be from the centuries after Hogarth, the examples of the English as observers also from the centuries before him.

As regards the English tendency to preach and to reform by art, we need only remember the flourishing of political caricature in England in Gillray's day [6], that is about 1800 – a considerable time before Daumier in France. Hogarth can be called the father of English caricature, although he has made it amply clear in the caption to his *The Bench* of 1758 that his aim was to draw character, not to caricature it. He is primarily concerned with life and the way characters determine events. He criticizes social conditions as well, but he is only rarely a social critic first and foremost. The line of succession from Hogarth leads to Rowlandson rather than Gillray. Dickens alone could combine social criticism as fierce as Gillray's with humour as humane as Rowlandson's. Like Hogarth he was a preacher as well as a painter.

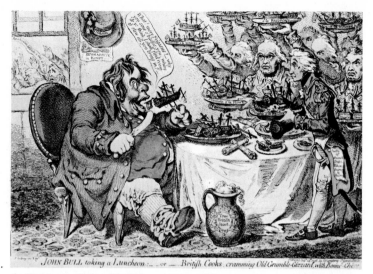

6. Because of the English concern with art as a story-teller and a moralizer, and also because of political liberty, the political cartoon flourished early in England. James Gillray, *John Bull taking a Luncheon*, 1798.

To continue now with the list of the preaching English painters, the Pre-Raphaelites come at once to one's mind, Millais's *Accepted* or his *Retribution*, Holman Hunt's *The Awakened Conscience* [7], or Ford Madox Brown's *Work*, with the honest navvies, the rich girl distributing edifying pamphlets, the children in rags, advertisements of the Working Men's College, and in the foreground Carlyle and F. D. Maurice out for a walk.[13] The art theory justifying such paintings is Ruskin's, who wrote that 'the art of any country is an exact exponent of its ethical life',[14] that painters 'cannot be great unless they are (in the broad human and ethical sense) Good', that the Dutch painters painted mostly a 'besotted, vicious, and vulgar human life',[15] and that 'the great arts . . . can have but three principal directions of purpose: – first, that of enforcing the religion of men; secondly, that of perfecting their ethical state; thirdly, that of doing them material service'.[16] Ruskin even extended this doctrine, against all probability, to architecture: 'The book

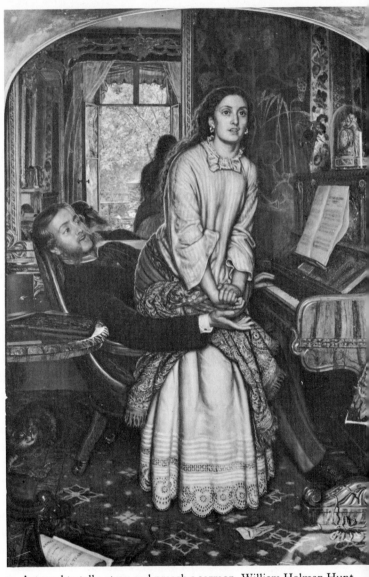

7. Art used to tell a story and preach a sermon. William Holman Hunt, *The Awakened Conscience*, 1854. Collection Sir Colin Anderson, London.

I called *The Seven Lamps* was to show that certain right states of temper and moral feeling were the magic powers by which all good architecture, without exception, has been produced.'[17]

So much for the artist and architect as a preacher. Now, the other aspect of Hogarth's work and intentions: the artist as an observer. In this Hogarth was even more universally English. Here it must first of all be remembered that nearly all the greatest painting of the British school is either man observed or nature observed, either portrait or landscape: Constable and Turner, and the water-colourists from Cozens to Cotman, and Gainsborough, Reynolds, Romney, and so on. Equally significant is the concern of the mid nineteenth century with the accurate rendering of observed life[18] in Frith's *Derby Day*, and *Paddington Station* [8], and *Ramsgate Sands*, as well as in the paintings of the Pre-Raphaelites. Who but an Englishman would have felt the need to go to the Holy Land to paint *The Scapegoat*, because the Scapegoat must appear in the picture driven into the real Dead Sea and not an imagined equivalent? It is to some extent the same attitude that made Hogarth paint his Gaoler before the Parliamentary Committee, that made first Edward Penny and then the American Benjamin West choose contemporary dress for their pictures of the *Death of General Wolfe* (1764 and 1771), that made the other American, J. Singleton Copley, paint in London in 1778 the first news-report on a large scale, his picture of *Brook Watson and the Shark*, and that made so romantic an artist as Joseph Wright of Derby take a keen interest in science and industry and illustrate them in his large pictures with large figures of *An Experiment with an Air Pump* (1768) and an *Iron Forge* (1772).

But this keen observing and quick recording is not only English of the last two centuries; it goes right back to the Middle Ages. On the pages of illuminated manuscripts of the later Gothic centuries a strange habit can be observed. Jesus Christ may be in the middle of the page, but the margins are covered with birds and beasts and little scenes from everyday

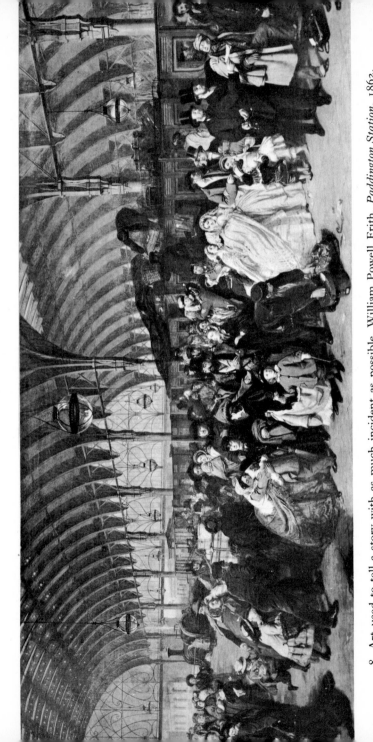

8. Art used to tell a story with as much incident as possible. William Powell Frith, *Paddington Station*, 1862. Royal Holloway College, Egham.

quia mira
bilia fecit.⊠
Saluauir
fibi dertam euis: 4bradinum firn er.²
Douum fecit dūs falutare fuū: in

9. Detail from a page of the Gorleston Psalter, *c.* 1300. Dyson Perrins Collection, Malvern. Babooneries as introduced into illumination in England about 1250. Genre scenes as well as grotesque monsters.

life and grotesque caricatures of such scenes. These things were called babwyneries, that is babooneries or monkey-business [9].[19] They were beloved by the artists of all countries, and to tolerate them is undeniably medieval rather than English – the *naïveté* which allows the immediate neighbourhood of tragedy and laughter. But if one tries to trace the baboonery to its source, one finds that it originated in England. Here it appears already at the classic Gothic moment, in the middle of the thirteenth century, and by 1300 it had become a universal English fashion – just at the moment when the religious representations on the same pages had become most exquisite, sophisticated, and often most exacting in their emotional intensity. The polarity expressed in this will engage our attention later. As regards the marginal grotesques, they are to be found in the Rutland Psalter and the Bible of William of Devon, both written about 1250, the Missal of Henry of Chichester of about 1260, the Psalter of Alfonso of 1284, and then in the more famous Ormesby and Gorleston Psalters.[20] The margins of the immensely copiously

10. OBSERVED LIFE. (a) Detail from a page of the Luttrell Psalter, *c.* 1340. British Museum, London. Dogs attacking a chained bear. (b) Detail from Hogarth's *Chairing the Member.* Sir John Soane's Museum, London.

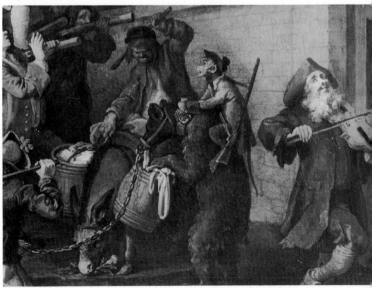

illustrated Queen Mary's Psalter show a ploughman and wrest-
lers, a man beating down acorns for his pigs, a windmill, hounds
chasing hares, and a mock funeral conducted by rabbits – with no
more respect and decorum than Hogarth. In some cases indeed
the parallelism between the babooneries and details from Hogarth
paintings and engravings is quite startling [9, 10, and 14].[21]

And once attention has been focused on this English interest
in the everyday world observed, it will at once be noticed also
in the misericords or pity-seats of choir stalls carved from the
thirteenth to the sixteenth centuries,[22] with illustrations of a

11. OBSERVED LIFE: two misericords (a) tapster from Ludlow
Parish Church, 1495; and (b) a shepherd from Winchester College
Chapel, 1390.

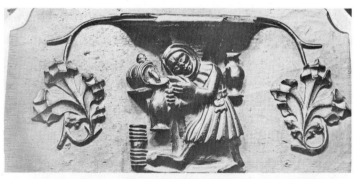

shepherd and his sheep [11a], the owl mobbed by the little birds, a jester, boat-builders, a tapster [11b], footballers, and a wife beating up her husband. This is only a small section of the genre scenes and genre figures which occur on misericords. They occur nearly as copiously on the capitals and bosses of thirteenth-century cathedrals, at Wells, at Lincoln, at Exeter, and so on [12; see also 85a, p. 168].[23] Or, to go yet further back, to about 1140, the same zest makes itself felt in such details of English Norman sculpture as the grave-diggers on one of the two big reliefs at Chichester Cathedral which once belonged to a chancel screen. And finally, back another sixty years, one reaches the Bayeux Tapestry, now recognized as an English work of about

12. OBSERVED LIFE: boss from the Angel Choir, Lincoln Cathedral, *c*. 1260. Two wrestlers.

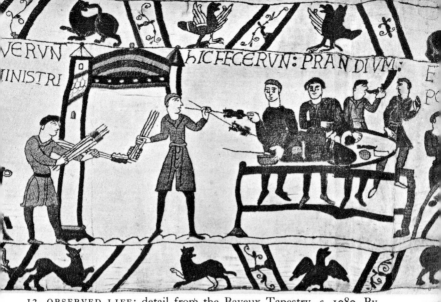

13. OBSERVED LIFE: detail from the Bayeux Tapestry, *c.* 1080. By courtesy of Victoria and Albert Museum, London. Serving at a banquet.

1080.[24] Here the story itself is told with an amazing wealth of incident – soldiers wading in the water, their surcoats tucked up high, a sailor looking out from the top of a mast, the roast served on long spits [13] – and along the top and bottom borders of the long strip which tells the story, one finds a ploughman again [14b], then what seems to be an act of indecent assault, and a huntsman blowing his horn. No continental country has anything like these riches of observed life in medieval art.

Medieval English chronicles are equally observant and lively in their descriptions. Dr Otto Lehmann-Brockhaus at Munich has just, after twenty-five years of work, completed publishing a five-volume collection of the evidence on English medieval art and architecture as found in chronicles[25] and his findings as summarized in a letter of 19 January 1955 are that, 'The English sources, especially in the twelfth century, as against those of other countries, are characterized by a far more vivid description with occasional criticism and even an occasional joke.' He stresses specially Abbot Ingulf's description of the fire at Croyland Abbey in 1109, Gervase's famous story of the fire and rebuilding

at Canterbury Cathedral in the 1170s, and Jocelyn de Brakelonde's description of monastic life at Bury St Edmunds about 1200.

This preference for the observed fact and the personal experience is indeed, as is universally known, the hall-mark of English philosophy through the ages. Here much more obviously than in art or literature, one approach has been consistently applied. Whether one thinks of the Utilitarians of the nineteenth century or of Francis Bacon or of Roger Bacon, Duns and Occam, they all have in common their unshakable faith in reason and

14. OBSERVED LIFE: details from (a) a page of the Luttrell Psalter, c. 1340 (British Museum, London); and (b) the Bayeux Tapestry, c. 1080 (Bayeux Cathedral). Ploughman.

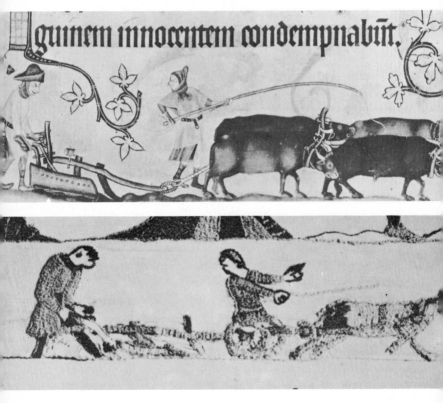

experience. Francis Bacon, whom Voltaire calls the father of experimental philosophy, said: 'Those who determine not to conjecture and guess but to find out and know . . . must consult only things themselves.' Roger Bacon in the mid thirteenth century wrote: '*Oportet omnia certificari per viam experientiae*' and '*Argumentum non sufficit, sed experientia.*'[26] A little after Bacon, Duns Scotus called theology *sapientia* not *scientia*, and Occam defined knowledge as what is known *per experientiam* and denied the existence of universalia, that is general ideas beyond the individual facts, and a little before Bacon, Adelard of Bath called authority a *capistrum* or halter.[27] Such an attitude to knowledge and reason and the independence of the individual can to a much more limited extent even be traced back to Scotus Eriugena, an Irishman of the ninth century, and to Pelagius in the fifth century.

It will be observed that in this hurried survey of philosophy the English, the Scots, and the Irish all appear as witnesses; for it seems indeed impossible to establish an Englishness as distinct from Scottishness and Irishness in the Middle Ages. How far it is possible in later centuries remains to be seen.

To return after this digression to the visual arts, it is tempting to examine how far the qualities analysed apropos Hogarth can also be in evidence in architecture. Two suggestions may be made, one proceeding relatively simply from Hogarth's use of his art to help practical purposes and reach the masses even at the expense of the finer qualities which are bound to get lost between painting and cheap reproductive engraving, the other linking up in a less obvious way with Hogarth's delight in narrative rather than composition.

England in the eighteenth century was the most resolute country to pass from craftsmanship to quantity production. The business papers of Wedgwood's [61b, p. 126] are one proof of this, those of the ironworks of Shropshire another.[28] This fact is of course connected with the unparalleled precocity of the Industrial Revolution in England, and the reasons for this are

outside art and certainly outside the present context. Another effect of this early development is that the architecture of the spinning-mill, that most matter-of-fact, most utilitarian, most workaday architecture of the eighteenth and early nineteenth centuries is originally English, and so is the architecture of the dock warehouse, the iron bridge [15a], and the Crystal Palace [15b].

This logical unperturbed distinction between the utilitarian and the ornamental, that is useful art and useless art, could only be made in England. It could perhaps only be made here, because in the practical, handy, inventive Englishman who rather makes a thing himself than relies on others to make it there is an anti-aesthetic streak, and design had to turn anti-aesthetic to evolve a technique rather than a style for bridges and warehouses. This anti-aesthetic tendency in one significant type of Englishman has had effects as fatal to nineteenth-century painting as the distinction between utilitarian and ornamental has had on nineteenth-century architecture, and the distinction between small-scale and large-scale production on nineteenth-century design. That, however, does not concern us for the time being.

What, however, does concern us immediately is another unwelcome aspect of nineteenth-century architecture and its English eighteenth-century origins. England was the first country to break the unity of interior and exterior and wrap buildings up in clothes not made for them but for buildings of other ages and purposes. Your country-house might be Grecian or Gothic, a summer-house in a garden even Chinese or Moorish. After 1830 a club would be like the palace of a princely merchant in Italy [16a], a grammar school would be Gothic, a gaol Romanesque or Gothic [16b], but in any case battlemented, and so on. It is no accident that this architectural historicism started in England; for in England there existed, as we have seen, a disposition in favour of narrative, and the thatched Old English cottages as against the Italianate villas tell a story by their very costumes. Their effect is evocative, not strictly aesthetic.

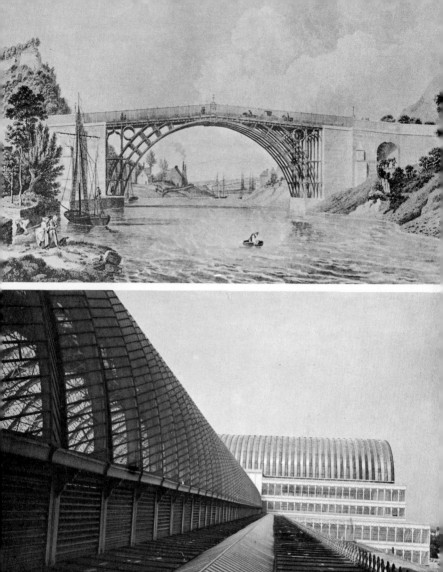

15. The openness of the English to realities and their unconcern with the Grand Manner has made England the forcing-house of industrially made architecture. (a) The iron bridge at Coalbrookdale, 1778; and (b) the Crystal Palace as re-erected at Sydenham in 1854.

The possibilities of an evocative architecture had indeed been explored uncommonly early in England too. Vanbrugh in his memorandum of 1709 on the preservation of the ancient manor-house of Woodstock wrote that certain buildings are valued highly by us, because 'they move more lively and pleasing Reflections . . . On the persons who have Inhabited them; On the Remarkable things which have been transacted in them; On the extraordinary Occasions of Erecting them.'[29] And Reynolds took the same thesis up in his Thirteenth Discourse and spoke of the power of architecture to affect 'the imagination by means of association of ideas'. He refers explicitly to Vanbrugh's own buildings in this context and their 'recourse to some of the principles of the Gothic Architecture'.

Now, this free selection of an associatively suitable style has yet another aspect. The architect in thus selecting proves not to be driven to express himself in one style and one style only: his own or that of his age. That single-mindedness is lacking, just as it is in Hogarth as a painter or indeed in the landscape-gardener – and the landscape garden is again an English invention and the most important of all, as will be proved – who places and designs his seats, and temples, and urns on pedestals to create moods.

Making England responsible for the fancy-dress ball of architecture in the Victorian Age is not complimentary to the aesthetic genius of the nation. Nor is it perhaps complimentary to stress the concern of the English with narrative. But two things must not be forgotten. First that the discovery of reality in the Middle Ages was a great and constructive effort, even if England – as so often – in the end refused to go the whole way and left the final achievement of realism to painters like the brothers Limbourg and Jan van Eyck.

And secondly painting, because it tells a contemporary story, need not be bad painting. Why should it be worse than painting to tell about Venus or Neptune or St Jerome? This brings us back once more to Hogarth. Hogarth was in fact a brilliant

16. Architecture also is specially inclined in England to tell a story, that is to put on a costume chosen to conjure up certain literary, evocative, or associational ideas. (a) The Reform Club in London, by Sir Charles Barry, 1837–40; and (b) the Holloway Prison in London, by J. A. Bunning, 1849–51.

painter. His stories are dashed off with vehemence, and his paint is creamy and runs in juicy curves and scrolls and whirlpools. This sensuousness of handling and this *brio*, and also Hogarth's delight in the feminine body half-exposed and in equivocal situations – all this was something quite new in English art. On the Continent such a free and open technique and such an exuberant sensuality had been introduced by Titian and developed by Rubens and many of the great and small painters of the Baroque. Hogarth in his succulent paint and also in the robust directness of his portraits represents this international Baroque in England.

As regards robustness English architecture had possessed it in the fifteenth century, but treated in a hard and angular, not a sensuous way. As regards a delight in curvy, scrolly forms, this had been typical of English architecture of about 1300, but it was then concerned with linear, almost disembodied forms, not with the rotundities of Hogarth.

So in this particular respect Hogarth, apart from being himself a unique individual genius with a style all personally his own, represents the spirit of his age. And this spirit of the age was not one with which England could have been by her nature in immediate sympathy. A parallel and exactly contemporary case is that of Vanbrugh and Hawksmoor in architecture. But in Vanbrugh this seeming contradiction with English possibilities can easily be explained by his Flemish descent. And besides, neither Vanbrugh nor Hawksmoor is really continental in his Baroque massing. Their groups always remain angular and their motifs classical – both qualities which will be analysed in their Englishness later. Even so, however, Hawksmoor, as Hogarth, though perhaps to a lesser degree, represents the spirit of the age modifying English capacities.

In the case of Hogarth the spirit of the age appears in yet other interesting and seemingly contradictory ways influencing his work. In 1753 he brought out a book on the theory of art. He called it *The Analysis of Beauty*, and its essence was the praise of

what he calls 'the line of beauty' – a shallow, elegant, undulating double curve. Now the fondness for these double curves is actually, although Hogarth did not know that, a profound English tradition, one that runs, as we shall see, from the style of 1300 to Blake and beyond. But it is also an international principle of the Late Baroque and Rococo, and it will be found without any effort in individual figures and whole compositions of Watteau in France, of Tiepolo in Venice, of Ignaz Günther, the greatest German sculptor of the century, of Roubiliac, the Frenchman, who was the great sculptor of that time working in England, of early Dresden china, and of Rococo plaster-work on ceilings, Rococo woodwork surrounding mirrors, and so on.

So, while in the case of Hogarth's Baroque modelling and brushwork an international quality created something in England that had not before existed within the English possibilities, in the case of serpentine or zigzag compositions and attitudes, an English quality in Hogarth and an international quality of Hogarth's age worked hand in hand.

Hogarth's moralizing is another case of such combined operations. How English it is, has been shown. But it is also a general tendency of an age which is called the age of reason and enlightenment. Only – and this complicates the situation yet more – Hogarth's figures stand, and behave as Rococo figures, but play roles assigned to them by an inventor who was in conscious sympathy with the rational, moral, that is anti-Rococo, tendencies of the eighteenth century. Hogarth is both Rococo and anti-Rococo, a rare phenomenon, and one incidentally that made it possible for him and for England altogether to enact such a prodigious influence on the whole Continent later in the eighteenth century. At the moment when Europe decided to abandon the Rococo, English rationalism was a welcome discovery, doubly welcome where its forms were not yet completely opposed to those to which artists of the continental Rococo were used.

Hogarth's contents certainly were. They could not be appreciated until the artificialities of the courtly French Rococo and

the enthusiasms of the religious South German Rococo had run their course. For Hogarth, and this is yet another angle from which his work must here be considered, was a man of the middle class and a man of the *juste milieu*. He castigated the inertia of the Church of England in his *Sleeping Congregation* but even more vehemently the excesses of the new piety in *Credulity, Superstition and Fanaticism*. And he did not only belong to the middle class, he did so demonstratively. His sisters sold frocks and haberdashery. In that alone there was nothing new. The majority of artists through his and the preceding century came, one can safely state, from such a class. But Hogarth differed from the others in that he squarely stood for the ideals of his own class instead of representing in his art, as was customary, the ideals of the class for which he worked. Proof of this is that curious dedicatory page which was written for a projected supplement to *The Analysis of Beauty* and is called the No Dedication.[30] It starts as follows:

The no Dedication
Not dedicated to any prince in Christendom for fear it might be thought an idle piece of Arrogance.
Not dedicated to any man of quality for fear it might be thought too assuming.
not dedicated to any learned body of men, or either of the universities, or the Royal Society, for fear it might be thought an uncommon piece of vanity
nor dedicated to any one particular friend for fear of offending another
Therefore dedicated to nobody
But if for once we may suppose nobody to be everybody, as every body is often said to be nobody, then is this work dedicated to every body
　　by their most humble and devoted
　　　　　William Hogarth

There once again is Hogarth addressing the people, that is from our present point of view, addressing his own class. His

challenge to patronage must have been written down at about the same time that Dr Johnson in his famous letter to Lord Chesterfield wrote: 'Is not a Patron, my Lord, one who looks with unconcern on a man struggling for life in the water, and, when he has reached ground, encumbers him with help?'

In both these cases the historian would argue that the *tiers état* expresses itself in the spirit of, though thirty-five years before, the French Revolution. Yet, even here, though class speaks most audibly, national character is by no means silent. For in the eighteenth century, England's, as compared with France's, Italy's, or Germany's, was predominantly a middle-class civilization. The middle-class tragedy of Lillo and novels of Richardson had wide European effects, and though Fielding, Hogarth's friend and the Hogarth of eighteenth-century literature, had his fun with Richardson, both stand together in their middle-class virtues and weaknesses. Nor was this a new attitude in England. On the contrary, it will be demonstrated later that Englishness had taken peculiarly middle-class features in at least one of its most English periods of history before.

3 REYNOLDS AND DETACHMENT

Sir Joshua Reynolds had no friendly feelings for Hogarth. It is true that when he was sixty-five he was ready to grant Hogarth within his own field of 'familiar scenes from common life' a mastery 'in which probably he will never be equalled'.[1] But eighteen years earlier, when Hogarth had been dead only six years, Reynolds was less lenient. Hogarth, he then said, expressed 'with precision the various shades of passion as they are exhibited by vulgar minds', and those, he added, who employ their pencil only on such 'low and confined subjects' can never 'enter into competition with the universal presiding idea of the art'.[2]

These passages come from the Discourses delivered by Reynolds at the prize-givings of the Royal Academy of which he was the first president. Hogarth, only a few years before the foundation of the Academy, had expressed himself with his usual outspokenness against 'the foolish parade' of an official academy on the French example.[3] Hogarth, being virulently anti-foreign as we have seen, even advised students not to travel to Italy. Reynolds had been in Rome for over two years and in his *Discourses* reiterated the necessity of such journeys for students. According to him they cannot develop their art without a knowledge of classical antiquity. Hogarth's comment on the many

so-called books of orders, English, French, and Italian, which were current amongst students and architects and which contained the five orders of columns of classical architecture (Doric, Tuscan, Ionic, Corinthian, and Composite) with all their details – the most famous were by Vignola, Palladio, and Scamozzi – was his *The Five Orders of Periwigs*, an engraving published in 1761. The Royal Academy was founded in 1768.

To feel to the full the contrast between Reynolds and Hogarth there is no better way than to look at their self-portraits, Hogarth's of 1745 in the Tate Gallery [1, p. 27], Reynolds's of

17. Sir Joshua Reynolds, self-portrait, 1773(?). Royal Academy, London. Reynolds appears as observant as Hogarth, but insists on displaying himself in a presidential attitude, against a bust of Michelangelo.

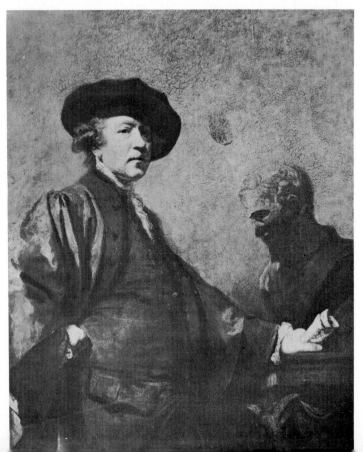

1773 [17] in the Royal Academy. Hogarth had a round face, with sensuous lips, and in his picture looks you straight in the face. He is accompanied by a pug-dog licking his lip and looking very much like his master. The dog sits in front of the painted oval frame in which the portrait appears – that is the Baroque trick of a picture within a picture. Reynolds scorns such tricks. His official self-portrait shows him in an elegant pose with his glove in his hand, the body fitting nicely into the noble triangular outline which Raphael and Titian had favoured, and behind him on the right appears a bust of Michelangelo.

This portrait is clearly as programmatic as Hogarth's. Reynolds's programme is known to us in the greatest detail. He gave altogether fifteen discourses to the students of the Academy, and they were all printed. And whereas Hogarth's *Analysis of Beauty* was admired by few and neglected by most – a crotchety book with touches of genius in surprising places – Reynolds's *Discourses* were international reading, owned for instance by Queen Marie-Antoinette and the Empress Catherine the Great of Russia and translated at once into French, German, and Italian.[4]

What did Reynolds plead for? His is on the whole a consistent theory. 'Study the great masters . . . who have stood the test of ages',[5] and especially 'study the works of the ancient sculptors'.[6] Copy 'those choice parts' from them 'which have recommended the work to notice';[7] for 'it is by being conversant with the invention of others that we learn to invent'.[8] Don't be 'a mere copier of nature', don't 'amuse mankind with the minute neatness of your imitations', 'endeavour to impress them by the grandeur of . . . ideas'.[9] That is what the Italians call *gusto grande* and the French *beau idéal*. Don't strive for 'dazzling elegancies' of brushwork either;[10] form is superior to colour, as idea is to ornament. The history painter is the painter of the highest order; for a subject ought to be 'generally interesting'.[11] It is his right and duty to 'deviate from vulgar and strict historical truth'.[12] So Reynolds would not have been tempted by the

reporter's attitude to the painting of important contemporary events, as Thornhill had been. With such views on vulgar truth and general ideas, the portrait painter is *ipso facto* inferior to the history painter. Genre (as we have seen in Reynolds's comments on Hogarth), and landscape and still-life rank even lower. The student ought to keep his 'principal attention fixed upon the higher excellencies. If you compass them, and compass nothing more, you are still in the first class . . . You may be very imperfect, but still you are an imperfect artist of the highest order.'[13]

This is clearly a consistent theory, and it is that of the Italian and even more the French seventeenth century, of Dufresnoy and Félibien.[14] There is nothing specifically English in it. But what is eminently English about Reynolds and his *Discourses* is the far-reaching contrast between them and him – between what he preached and what he did. History painting and the Grand Manner, he told the students, is what they ought to aim at, but he was a portrait painter almost exclusively, and an extremely successful one. The great Roman painters Raphael, Michelangelo, and Annibale Carracci ought to be the English painter's examples, but his were Titian and Rembrandt, though he blames Rembrandt for 'taking individual nature just as he finds it'.[15]

How can this contradiction be explained? Is it hypocrisy or, to use the term applied with some glee by the French and the Germans, cant? If hypocrisy or cant by definition imply that dishonesty has ceased to be conscious and become second nature, then the word certainly has no validity in the case of Reynolds. He was only too well aware of the discrepancy between his theory and his practice. Already in 1770 he said: 'A man is not weak, though he may not be able to wield the club of Hercules; nor does a man always practice that which he esteems the best, but does that which he can do best.'[16] I need hardly stress how much this statement contradicts his advice to the students. At the end of his life, in his last Discourse, he was

more melancholy. He ended a long passage on the exalted per-
fection of Michelangelo by saying: 'I have taken another course,
one more suited to my abilities, and to the taste of the times in
which I live. . . . Yet were I now to begin the world again, I
would tread in the steps of that great master.'[17]

But what is all this, if it is not hypocrisy? Perhaps one ought to
use the less offensive, though in a world of aesthetics also highly
dubious, term compromise. Reynolds's official portraits in any
case are a blatant example of compromise. He recommended
that to raise portraiture to the higher excellencies of art the artist
ought to enlarge the subject 'to a general idea',[18] e.g. by chang-
ing 'the dress from a temporary fashion to one more permanent
or by ennobling the character of a countenance'[19] even at the
expense of likeness. That is the explanation of his *Miss Morris
as Hope Nursing Love*, his *Mary Mayer as Hebe*, his *Mrs Crewe
as Ste Geneviève*, or *Lady Sarah Bunbury sacrificing to the Graces*
[18], and also of borrowing the composition of *Mrs Hartley as
a Bacchante* from Michelangelo's *Doni Madonna*.[20]

The theory does not satisfy us. We are inclined to think that
an understanding of what is individual in a person if coupled
with 'dazzling elegancies' of the brush is more profitable than
such a general idea as Hebe. We may respect Reynolds's *Mrs
Siddons as the Tragic Muse* [19a] and intellectually appreciate its
subtle dependence on the Prophets of Michelangelo's paintings
in the Sistine Chapel [19 b and c], but when we look at Gains-
borough's portrait we are thrilled by Mrs Siddons the actress
[20] as she must have been in life – just as we are thrilled by
Hogarth's portrait of Captain Coram, as he must have been in life,
or of the Arnolds, father and daughter, at the Fitzwilliam Museum
in Cambridge, though we know nothing much of who they were.

Reynolds, however, without any doubt, was in earnest with
his recommendation of the learned composition and the learned
content to raise portraiture above a mere art of the brush. Nor
was there anything of sour grapes in his low estimate of painting
as painting. It is sufficient to look at his *Nelly O'Brien* [21] in the

18. Sir Joshua Reynolds, *Lady Sarah Bunbury sacrificing to the Graces*, 1765. Art Institute, Chicago. The portrait raised to a general idea. Subdued characterization and attitude.

19. (a) Sir Joshua Reynolds, *Mrs Siddons as the Tragic Muse*, 1784. Dulwich College Picture Gallery. The portrait raised to a general idea. Setting and attitude have unmistakable allusions to (b and c) Michelangelo's Prophets from the ceiling of the Sistine Chapel.

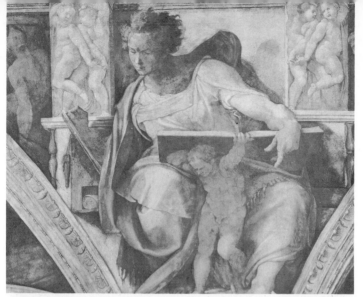

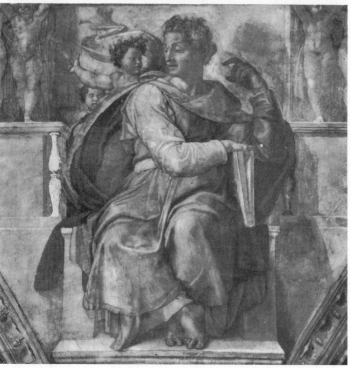

Wallace Collection with the subtle pale rose and striped white and light blue in her dress and with the beautiful lights on her throat and shaded pinks in her face to realize that Reynolds's artistry and sensitivity to nature were in no way inferior to Hogarth's or indeed Gainsborough's. Or one may look at a late more boldly and thickly painted portrait such as the *Brummell Children* at Ken Wood, and one will see again how his colour expresses that very 'bustle and tumult'[21] of which he disapproved, and how his interpretation can be direct, lively, and not in the least cramped by general ideas. But it was the *Lady*

20. Thomas Gainsborough, *Mrs Siddons*, 1785. National Gallery, London. Realistic portraiture, but as subdued in attitude and characterization as Reynolds's portraits.

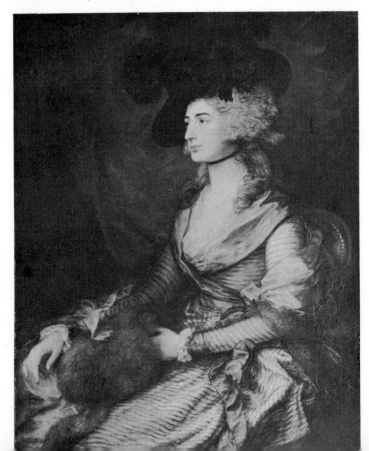

Blake as Juno receiving the girdle from Venus and such-like portraits that he sent in to the newly founded Academy.

The case of these discrepancies between doctrine and practice in Reynolds has now been described. It is time to look at it from the point of view of its Englishness. There is first of all of course, as has been said before, plenty that is English in the fact that Reynolds painted portraits and not mythology and saints as they did for instance in Italy, and also in the fact that his portraits are so remarkably reticent. But that does not concern us at this stage. For the moment the principal problem is still that of cant

21. Sir Joshua Reynolds, *Nelly O'Brien*, 1760–2. Wallace Collection, London. Reynolds, in spite of his insistence on the general idea, was by no means inferior as a painter to Gainsborough.

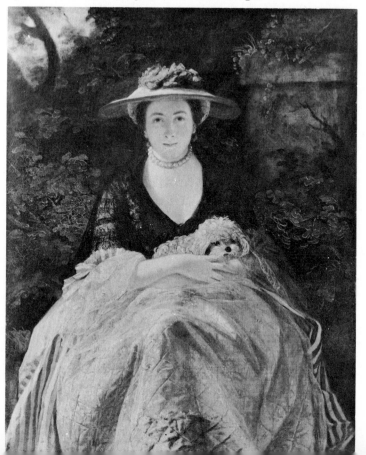

or compromise. It is a most English problem, and it is by no means always easy to see where the border runs.

If, as G. M. Young tells us, a manufacturer in the Bleak Age kept children of nine at work for nine hours at a temperature of ninety-eight degrees, and let them sing hymns, that is cant at its worst.[22]

If the Church of England insists on the apostolic succession to prove its catholicity, it is hard to decide what it is, and things are not made easier by the quandary in which one finds one-self between distaste for the unsavoury circumstances of Henry VIII's Reformation and respect for the wisdom of Queen Elizabeth's Settlement. If Reynolds exemplifies how a painter can adhere to the Grand Manner without adhering to the Grand Manner, the Church of England demonstrates how one can be catholic without being Catholic, and occasionally protestant almost without being Protestant. The author of a brilliant book on Tudor England[23] says that 'Luther plunged impetuously forward into the quagmire of doctrine, [while] Henry refused to budge from the firmer ground of organization.' It is doubtful whether there is anything to be proud of in this, and Mr Rowse's consistent refusal both in his best book[24] and in his later books to respect those in the later sixteenth century who sacrificed their lives for their faith, shows at its worst this absence of under-standing of singleness of mind. On the other hand, although it is true that the Elizabethan Settlement 'kindled no flame in men's hearts' and was 'designed to appeal to the lukewarm multi-tude',[25] that very lukewarmness saved England much of the horrors of the wars of religion in France, the Netherlands, and Germany.'

The final outcome of this, three hundred years later, is such a statement as that made by the Judicial Committee of the Privy Council in the Voysey case of 1871, that clergymen 'may follow any interpretations of the Articles, which, by any reasonable allowance for the variety of human opinion, can be reconciled with their language'.[26]

Compromise cannot well go further. The foreigner stands baffled and confused. He may well be equally baffled by another example of English compromise which will take us back to art. William Morris, designer, poet, and social reformer, preached with tremendous vigour that all healthy art must be 'by the people for the people'. But meanwhile he made in his workshops the most wonderful woven stuffs so expensive as to be accessible only to a relatively few appreciative patrons. Like Reynolds he was not blind to this contradiction. We are told that one day a friend found him busy with the interior decoration for a private house, and when he was asked what he was doing, he answered that he was 'serving the swinish luxury of the rich'.[27] How can that be reconciled with the furious socialism and the furious integrity of the man? Can it be that this very fury of thought and action clouded all logic? Or perhaps is illogicality another national characteristic? That is no doubt the case, and fascinating illogicalities in English architecture of diverse ages will be considered later. For the time being it is enough to remember how close to each other dwell illogicality, compromise, and cant in the English heart, and to realize – which is the next step – that 'Every case on its own merit' is only a fourth facet of this same quality. This needs stressing; for, while hypocrisy always is, and illogicality can be, highly irritating and infuriating, 'Every case on its own merit' is one of the greatest blessings of English civilization, whether one is dealing with the higher walks of administration or with some detail of daily life.

Now to judge every case on its own merit requires a dispassionate study. If you are biased by principles, or preconceived notions, or prejudice, you cannot judge objectively. So detachment is the corollary of 'Every case on its own merit', and detachment leads us back to English art, to Thornhill's cool and intelligent weighing-up of the possibilities of the realistic as against the semi-allegorical representation of contemporary events, to Hogarth's equally cool decision to paint one type of picture as against any other, to Robert Adam who, on the

testimony of recently discovered but so far only partially and inadequately published letters, was equally determined on making a career and bending his programme and his style to that purpose,[28] and also to Reynolds and some unforeseen aspects of his art.

Reynolds, who praised Raphael and Michelangelo so highly, had seen and studied their work in Rome. But his immediate reaction to Raphael's immortal *School of Athens* [22b], a monument so noble, so calm, was that he painted a parody of it with caricatured English virtuosi in the place of Raphael's Greek philosophers [22a]. Reynolds even admitted in his last Discourse that the first sight of the great art of Renaissance Rome is a disappointment to the young English painter and recommended that we ought 'to feign a relish till we find a relish come'.[29] That is the ingredient of hypocrisy in it; the ingredient of detachment is that Reynolds did not only paint Mrs Crewe as Ste Geneviève, but also *Master Crewe as Henry VIII* [23] – a sturdy pink-cheeked little boy of four dressed up as Henry VIII and standing, legs wide apart, in the famous pose of Holbein's portrait of the King. That also is parody, but it is not simply parody of Holbein; it is an easy and superior play on several levels, none taken too seriously, a play with Holbein, the King, the boy, and also the grand portrait and those advocating it, including Reynolds himself.[30]

This again is significantly English. It might be compared with Lewis Carroll's attitude to the ballad as shown in *The Walrus and the Carpenter* and to processions of sonorous words as shown in ''Twas brillig', and it can certainly be compared with Reynolds's own attitude to his sitters, when he paints them in Van Dyck costume. The mood is hard to catch now, and the

22. (a) Sir Joshua Reynolds, *English Connoisseurs in Rome*, 1751. National Gallery of Ireland, Dublin. Not a contribution to the Grand Manner which Reynolds recommended to students, but a parody of it. (b) Raphael, *The School of Athens*, *c*. 1510. Vatican, Rome. The painting on which Reynolds modelled illustration 22a.

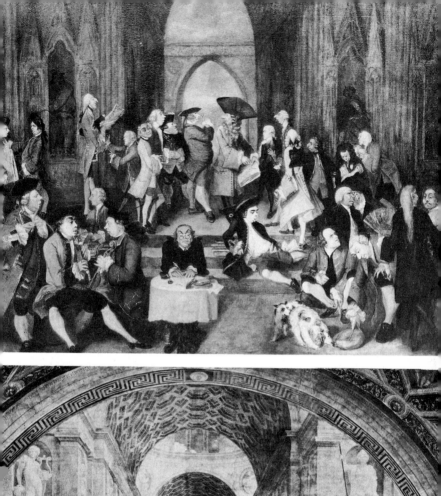

ambiguity one which is not only English but also Rococo in a European sense. The Veronese costumes of Tiepolo and others are the outcome of similar oscillations of mind. Only that in Italy the acting seems real whole-hearted acting, whereas in England the reticence of deportment half-defeats the costume. It makes it impossible to take the sitter or the picture too deadly seriously.

Almost identical is the attitude of Horace Walpole, Reynolds's contemporary, to his beloved Strawberry Hill. There can be no doubt that, if he felt seriously about anything, it was about this creation of his, this bijou villa which on another level was a

23. Sir Joshua Reynolds, *Master Crewe as Henry VIII*, 1776. Collection of the Marchioness of Crewe. An engaging parody of the Grand Manner and of pomposity.

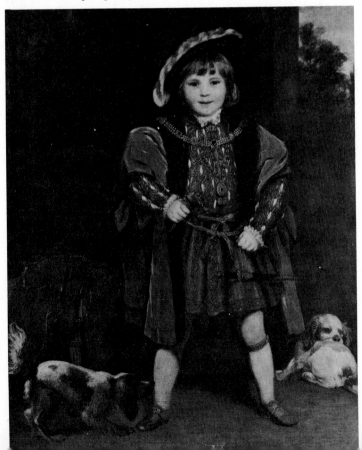

Castle of Otranto, and which he kept enlarging and embellishing for over twenty years. Yet in his letters he writes of it: 'My house is so monastic that we have a little hall decked with long saints in lean arched windows . . . which we call Paraclete.'[31]

In the previous chapter English Gothicism has been explained as an expression of the narrative as against the purely aesthetic interest. Now it must be added that it can also be seen as a sign of detachment as against passionate single-mindedness. The earliest documentarily certain case of a self-conscious Gothic Revival in architecture is that of the Library of St John's College at Cambridge [24].[32] Here, in 1624, Gothic windows instead of the Jacobean ones one would expect were chosen deliberately because, as the document says, 'some men of judgement like the best the old fashion of church windows, holding it most meet for such a building' as a College Library. Surely, here the whole detached attitude of the Gothic Revival is already complete, and it is essential to distinguish between such a self-conscious revival and the many contemporary and later cases of an unself-conscious survival. The one concerns us now, the other stems from different causes and will be discussed later. Sir Christopher Wren, some fifty years after the date of St John's College Library, continues the revival [25]. He put a Gothic tower, Tom Tower, on the Early Tudor gatehouse of Christ Church, Oxford, and gave to some of his City churches Gothic towers and spires. Later on he pronounced the opinion that they were 'not ungraceful but ornamental'. And for the completion of Westminster Abbey he strongly urged a continuation of the forms of the ancient building; for 'to deviate from the old Form, would be to run into a disagreeable Mixture'.[33]

After Wren the Medieval Revival never disappeared in England. On the Continent it only appeared fifty years later, and then under English influence. Vanbrugh's bastions and crenellations and polygonal turrets [26a], Hawksmoor's polygonal tower of St George's-in-the-East [26b], Kent's more playful Gothicisms, Sanderson Miller's sham ruins, and so on to Walpole

24. The Library of St John's College, Cambridge, 1624. The earliest provable case of the Gothic Revival. The underlying attitude is exactly as in Reynolds and Hogarth, that of a self-conscious choice of a mode of expression.

25. St Mary Aldermary, London, by Sir Christopher Wren, 1682. An example of the pleasure which even Wren could find in the reviving of a style of the past. Again a case of the self-conscious choice of a mode of expression.

and Strawberry Hill. There even was, though much less frequent, a parallel Jacobean Revival, heralded, it seems, by Vanbrugh,[34] let alone the *chinoiseries* of the mid eighteenth century and the Moorish and Indian frolics of Kew Gardens.

The attitude behind all this which has here been called detachment, the attitude which allows reflections on what style to choose for what job is one which, once it has been demonstrated in the seventeenth and eighteenth centuries, can even be recognized in certain medieval buildings in England and is there, it seems, without any parallel abroad. Henry Yevele, Master Mason of the King's Works, built the nave of Westminster Abbey [32, p. 84] from 1362 onwards, essentially in accordance with the system of elevation laid down a hundred years before by the first masons. The differences can easily be seen, once one

26. From Wren onwards Medieval Revival was never silenced in England. (a) Vanbrugh Castle, Blackheath, London, by Sir John Vanbrugh, 1717–*c.* 1726; and (b) the tower of St George's-in-the-East, Stepney, London, by Nicholas Hawksmoor, 1715–23.

watches for them, but to the superficial onlooker the building is all of a piece. That is in fact one of its outstanding qualities. It lacks the historical fascination of so composite a building as Ely or Canterbury Cathedrals, but it possesses a noble unity due entirely to the decision of Henry Yevele here to waive the Perpendicular style of his own generation for the sake of conformity. Nor is the case of Westminster Abbey unique. At Beverley Minster the same thing happened about 1320–50, again in continuation of work designed a century earlier. In this connexion attention may also be drawn to the romantic Gothicism of the Elizabethan Wollaton Hall, a revival also and not a survival, though not so consistent a one as at St John's College,[35] and to the even more curious cases of the same Elizabethan Age where funeral monuments were self-consciously made to look medieval. They have not yet been collected, but the volumes of *The Buildings of England* contain a number of them.[36]

The attitude common to all these cases is that of a self-conscious choice of style. Nicholas Hawksmoor, Wren's former amanuensis and one of the most brilliant, daring, and original architects England has ever produced, offered All Souls College about 1708–9 alternative façades for their proposed new buildings along the High Street, one in the English classical Baroque, the other in Gothic.[37] The method was accepted by about 1800. Nobody seems to have found anything wrong with this. Nor did anybody in other countries. Even Sir John Soane, the most original, uncompromising of English architects of the early nineteenth century did likewise [27]. Soane of course very rarely 'did likewise'. His mind was much too stubborn. Yet he allowed opposed styles not only for practical purposes, that is to please clients, but also in his own house, where classical and Gothic fragments jostle each other behind a highly original, neither classical nor Gothic façade.

A digression must here be allowed. Sir John Soane will be mentioned again in another context later, but his style is too personal, too idiosyncratic, to fit any system of period or national

27. Even so uncompromising an artist as Soane did not object to the choosing of one of several equivalent styles by a client. A church with elevations in different styles, by Sir John Soane, 1825.

classification completely [28]. It is the same as with Hawksmoor in the early eighteenth and Butterfield in the mid nineteenth century. These men were laws unto themselves – as indeed on an infinitely vaster scale was Shakespeare – and they can only be tenuously tied to the categories of national character. Perhaps the most promising attempt would be to link their very eccentricity with a streak in the English make-up often commented on. Spleen is the term used on the Continent for this English quality, the quality that has made England the land of Follies. The Brighton Pavilion is perhaps the most famous of all, and while this building has once before been alluded to as representing the English preference for architectural content over architectural form, and once for the detached choice of a style to trim up a house with, it can in its essence only be appreciated as the most lavish member of the delightful and crazy tribe of the Follies.[38] Follies run from the relatively simple and naïve job of the look-out tower of which one spectacular example of many is Lord Halifax's at Racton in Sussex which was built in 1770, was more than seventy feet tall originally, and cost £10,000, to such

small but elaborate fantasies as the farms at Greystoke Castle in Cumberland which were called Jefferson, Bunker's Hill, and Fort Putnam [29] and were heavily castellated. They were built by the eleventh Duke of Norfolk about 1780–5. Now he was painted by Gainsborough, and Lord Halifax by Reynolds.[39] Neither the one nor the other behaves in his portrait in any way that would betray follies, whether this may be due to the sitters' poker-faces – to use a piece of profoundly English slang – or to the painters' sense of decorum.

28. Dulwich College Art Gallery, by Sir John Soane, 1811–14. An example of the originality and eccentricity of Soane.

The detachment of the English eighteenth-century portrait, whether painted with the genius of Reynolds or Gainsborough or with the accomplished craft of all the others, will not be denied by anyone familiar with the contemporary portraits of France, Italy, and Germany. It was in fact this very restraint that impressed those on the Continent who set themselves the task of imitating it on the evidence of available engravings and mezzotints. Reticence or taciturnity was recognized as an aspect of the English character already at a much earlier date. Emerson in fact says that the reputation for taciturnity goes back 'six or seven hundred years'.[40] Muralt, the intelligent Swiss observer of England in the late seventeenth century, compares the English with their dogs, both 'taciturn, obstinate, lazy, intrepid, and stubborn in fight',[41] César de Saussure twenty-five years later comments on the long silences when Englishmen sit and converse,[41] the Abbé Leblanc about 1740 also calls them 'naturally

29. The folly in English architecture. Greystoke Castle, Cumberland, *c.* 1783. Farmhouse called Fort Putnam. A demonstration of eccentricity, but also a sign of political liberty; for the Greystoke follies are an encomium of American independence.

inclined to silence',[42] and the German pastor Wendeborn in 1793 notes, a little hurt, that the English when abroad prefer to dine in their rooms instead of at the *table d'hôte* and when at home prefer an empty table in a coffee-house to one where others are sitting. Poor Wendeborn was ready no doubt to start talking at the slightest provocation.[43]

Thus the English portrait also keeps long silences, and when it speaks, speaks in a low voice, just as the Englishman does to this day, and as indeed the muffled sound of the English language seems to demand. Or, to put it differently, the English portrait conceals more than it reveals, and what it reveals it reveals with studied understatement. These men and women illustrate what Jane Austen in *Emma* calls 'the true English style' by 'burying under a calmness that seems all but indifference, the real attachment'.[44] 'Dr Livingstone, I presume' is the *locus classicus* of this aspect of Englishness, and if that assertion is countered by a reminder of Shakespeare and the passions raging in his plays, one need not take refuge in the truth that Shakespeare is of a calibre to burst any categories into which one may try to force him, but one can equally refer to the words which he put into the mouth of Hamlet.[45] 'In the very torrent, tempest, and, as I may say, whirlwind of passion, you must acquire and beget a temperance that may give it smoothness.' He also warns that what is 'overdone . . . cannot but make the judicious grieve'.

There could be no better way of characterizing the portraits of Reynolds and Gainsborough: temperance, smoothness, judiciousness, moderation.[46] Temperance and moderation are the two terms which may now serve to round off the argument by a reference to the English climate and the English landscape. It is a moderate climate with no scorching heat nor paralysing cold. The effect which this has had on the art of gardening will be discussed later. And as for the English landscape, this is what William Morris in a memorable passage said about it:

Not much space for swelling into hugeness; . . . no great wastes overwhelming in their dreariness, no great solitudes of forests, no terrible

untrodden mountain walls; all is measured, mingled, varied, gliding easily one thing into another, little rivers, little plains . . . little hills, little mountains . . . neither prison, nor palace, but a decent home.[47]

A decent home, a temperate climate, and a moderate nation. It has its disadvantages in art. There is no Bach, no Beethoven, no Brahms. There is no Michelangelo, no Titian, no Rembrandt, no Dürer or Grünewald. There are no vast compositions in the churches, and only bad if vast compositions in the palaces, but there are exquisite water-colours and miniatures [85b, p. 168], things on a small scale, and there are in the Middle Ages exquisitely carved bosses and capitals [12, p. 44, and 85a, p. 168] rather than the superhuman *dramatis personae* of French church portals. England also produces a nice crop of amateur painters from maiden aunts to Prime Ministers, and what the amateur painter must be lacking in, in order to remain an amateur, is a violent compulsion towards a singleminded self-expression to which a lifetime must be devoted. The amateur is altogether characteristic of England, and not the specialist. This has much to recommend it. Another aspect of moderation is that the mid-nineteenth-century naturalism was not as obtrusive as Courbet's. It was that of the Pre-Raphaelites, and any comparison between even so subdued and old-masterly a painting as Courbet's *Stonebreakers* [30a] and John Brett's *Stonebreaker* [30b] will bring that home. Brett copies with the most loving care every leaf and stone, but he does not penetrate to the reality of the existence of a stonebreaker. Again, in the architecture of about 1900 there is in England the fresh yet friendly and human style of Voysey [31a], not the whole-hog throwing overboard of all traditions as in Frank Lloyd Wright in America [31b], in Garnier in France, in Behrens and Loos in Germany and Austria.

The revolution which led to the establishment of modern architecture was prepared step by step in England, first by Morris in theory and design, then by such architects as Voysey, but the revolution itself had to be made abroad. Revolutions in England are unbloody, like that of 1688 and that of the last

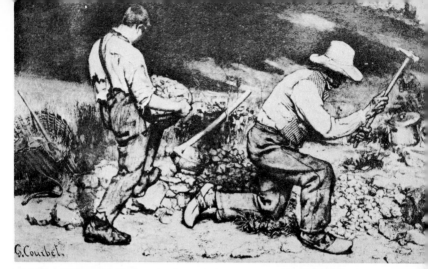

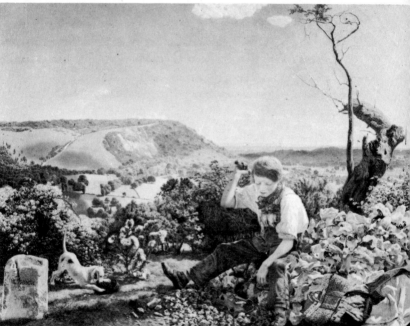

30. DISTRUST OF THE EXTREME: realism not too realistic. (a) Courbet's *Stonebreakers* of 1848, Dresden Gallery, contrasted with (b) John Brett's *Stonebreaker* of 1857–8, Walker Art Gallery, Liverpool.

twenty-five years. Everything changes, but names, formulas, the outer, demonstrative signs do not change. There are two causes for this, both equally English. One is reasonableness, and that is so all-pervading an English quality that it can at this stage be no more than mentioned. It found its first wholly valid expression in Perpendicular architecture and must have a chapter to itself in connexion with that. The other is conservatism, and for the significance of conservatism in English art a summary may be appended to this.

Some of the more puzzling phenomena of contemporary English conservatism have already been enumerated quickly and without comment – the Judge's wig, the Cinque Ports, and so on. They are without doubt immensely characteristic of twentieth-century England, and one cannot be proud of all of them – not of obsolete railway stations with unspeakably shabby and dreary waiting-rooms, nor of antediluvian dust-carts scattering more garbage than they collect, nor of museums in provincial towns – to return to art – where stuffed birds live side by side with paintings of some value and the snuff-box of some

31. DISTRUST OF THE EXTREME: the modern style in architecture, about 1900. (a) Charles F. A. Voysey (house at Puttenham, 1897) squared up all the details and strongly stressed the long window-band,

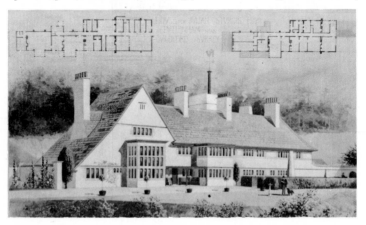

defunct citizen of the town. Here conservatism comes danger-
ously near inertia, and the Americans and Germans take it to be
a sign of old age and tiredness. Whether there is some truth in
this or not, there is certainly a warning in it, and it may be
unwise to stress, as will be done here, that conservatism can
have positive qualities: trust in the tried-out, distrust of experi-
ment for experiment's sake, and – most important – faith in
continuity and a dislike of breaks.

It is these positive qualities whose appearance in English art
must occupy our attention. If Henry Yevele continued West-
minster Abbey in a style then a hundred years old [32], clearly,
in order to avoid a break, did he not do, only more potently,
what the Norman builders had done in carrying on with the
excessively long naves of Anglo-Saxon churches, and the Early
Gothic builders had done in not shedding the Norman motif of
a full-scale gallery above the aisle arcades? In France this
voluminous piece of design was discarded about 1200, and
Chartres, Reims, Amiens, Beauvais, Cologne do not possess it.
But in England Lincoln [50, p. 109] and Salisbury and even the

but remained in general character close to his seventeenth-century
patterns. (b) Frank Lloyd Wright (Henderson House, Elmhurst,
Illinois, 1901) breaks with all traditions.

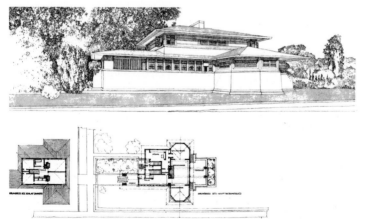

32. CONSERVATISM. The left part of the nave of Westminster Abbey, London, to the right of the transept, belongs to the original plan of 1245–c. 1260; the right part was begun by Henry Yevele in 1362. The style is self-consciously adapted to that of the thirteenth century. The architect hides his own (Perpendicular) style. One of the earliest cases of such self-consciously chosen conformity.

most French of English thirteenth-century churches, Westminster Abbey, kept faith in it.

There are other reasons for this as well, and they will come up later, but conservatism is certainly one reason. Conservatism also shows itself in the fact, so surprising to foreigners, that once the Perpendicular style had been created – that most English of architectural styles – it remained virtually unchanged for over a hundred years. To distinguish between the style of the Gloucester chancel of about 1350 [33a] and the Gloucester Lady Chapel of about 1450 [33b] is almost impossible. Nor is it at all easy to recognize development in English sculpture of the fifteenth century. Even the most recent treatment brought no enlightenment to those historians of art anxious to be able to date accurately what they see. If such dating is so much easier in the German fifteenth century, may not in this also a national difference appear, especially as exactly the same phenomenon is

repeated in English architecture of the eighteenth century? There also, once Palladio had been firmly established as the English amateur's and architect's guide and master, nothing changed for a hundred years, and it is by no means always possible to date the design of a Palladian house accurately even to a generation [34 a and b].

The medievalism of the English eighteenth century also comes into the problem of conservatism. It has engaged our attention already in connexion with the narrative interest of the English artist and in connexion with detachment in the choice

33. CONSERVATISM. Another aspect of conservatism is the persistence over two hundred years of the Perpendicular style without any essential changes. At Gloucester Cathedral (a) the chancel was begun in 1337 and (b) the Lady Chapel c. 1457.

34. CONSERVATISM. The persistence of the Palladian style in the Georgian Age is equally remarkable: (a) Wanstead House, Essex, by Colen Campbell, begun in 1715; and (b) Cumberland Terrace, London, by John Nash, begun in 1826.

of a suitable style for a building. Now it may be suggested that it is also a sign of conservatism. Wren suggested completing Westminster Abbey in the Gothic style, because 'to deviate from the old Form, would be to run into a disagreeable Mixture, which no Person of good Taste could relish'.[48]

But there was no doubt more than that in his sympathy with the Gothic style, as there was obviously more in Vanbrugh's medievalism. Proof in the case of Wren is the history of the plans for St Paul's. Wren's first and favourite plan was entirely un-English, as was his plan for the rebuilding of the City of London. The Cathedral was to be rebuilt on a central plan with an all-dominant dome. The clergy refused to accept so un-English a shape for their new cathedral, and Wren declared himself ready to revise his plan. The result is surprisingly traditional and English: a long nave, a long chancel, long transepts, all kept clearly separated from each other, nearer to Ely than to the Italian or French Baroque [35]. Wren's cathedral even possesses, though one cannot see it from below, a complete system of flying buttresses [36].

One final example of conservatism, in order to end with

35. Wren intended St Paul's to have a central plan, but at the request of the clergy he gave it its longitudinal form. The plan is surprisingly close to that of an English Norman cathedral, such as Ely.

36. CONSERVATISM: St Paul's Cathedral. Not only the plan of
Wren's, but also the construction is borrowed from the Middle Ages.
Behind the screen-wall (on the left) which hides the aisle roofs are
flying buttresses to support the nave vault.

37. CONSERVATISM. English conservatism appears as early as the
twelfth century. (a) The Utrecht Psalter of *c.* 830, kept at the time at
Canterbury Cathedral, and (b) one of several copies of it: the Eadwin
Psalter of *c.* 1150, at Trinity College, Cambridge.

painting in a chapter set aside for problems arising out of the work of a painter. English medieval painting affords a striking example of conservatism. It has recently been demonstrated in Dr Swarzenski's *Monuments of Romanesque Art*. One of the most famous Carolingian manuscripts, the Utrecht Psalter [37a], written about 830, belonged to Canterbury in the centuries to follow. Its scintillating technique of line-drawing influenced England much, because, as we shall see later, it responded to a specifically English, perhaps originally Celtic, urge. Whatever the reason, the manuscript was copied with curious consistency in England [37b]. The copying of manuscripts and modifications introduced in such copies were of course a custom of the Middle Ages in all countries. Yet the series of copies illustrated by Dr Swarzenski is surprising all the same – as it goes on from the early eleventh century, to the mid twelfth and even the early thirteenth.

Here surely something was already at work of the same kind as Wren's sense of becoming conformity in putting Tom Tower on Cardinal Wolsey's gatehouse at Christ Church, and Henry Yevele's sense of becoming conformity in preferring at Westminster an only slightly modified Early English to the Perpendicular of his own style and his own age. It is to the Perpendicular in its other aspects that we must now turn.

4 PERPENDICULAR ENGLAND

There is little that is in every respect so completely and so profoundly English as are the big English parish churches of the Late Middle Ages, the age of Henry V, Henry VI, Henry VII. Those of them which were built wholly afresh like King's Lynn or almost wholly afresh like Lavenham or Newark [38] are recognizable by their wide naves and equally wide aisles, by their tall proportions, their thin, sinewy, very emphatically perpendicular piers, their large aisle windows, and large clerestory windows with tracery of hard forms impressively, if monotonously, repeated, by their timber roofs of low pitch (instead of vaults), their chancels and transepts long, angular, and square-ended (instead of rounded ends or rounded or polygonal chapels), and their vast end windows in the chancel and the transepts and at the west end [39]. They make churches of that age veritable glasshouses, clear, light, vast, and not in the least mysterious. The effect must always have been like that; for figured glass was confined to selected areas surrounded by plenty of white, that is, transparent, glass.

This description of the English architecture of the style which for good reasons is known as Perpendicular, is correct, but it is one-sided. There are polarities even here, and if one could see a Perpendicular church with all its original furnishings, the effect

38. Newark: Perpendicular compartmentation.

39. THE PERPENDICULAR STYLE: St Mary, Nottingham, north transept, fifteenth century.

would perhaps be less of unbroken vastness and clarity. For there were plenty of screens and chantry chapels, of altars and reredoses and canopied funeral monuments to break the evenness of the architectural design, even if those pieces of interior fitting and furnishing themselves were often, compared especially with the brilliant fantasies of contemporary German work, very repetitive too. Screens, especially in the south-west, may be full of close, crisply carved detail, but it is surprising how standardized even they were. Major reredoses were large stone screens with an even grid of canopied niches for images, repeated without unnecessary displays of inventiveness. The sculpture in the niches was repetitive too, with little of the insistent individuality of such work in the churches of Bavaria, and as for funeral monuments, it is often found that figure sculpture is entirely or largely replaced by heraldry. In this the familiar English leanings to the informative rather than the imaginative in fine art appear again, but also the preference for repetition. Even so, however, all these pieces of interior enrichment counteracted the squareness and bareness of the original framework. Equally effective in the same direction are the stone vaults with their patterns of innumerable small ribs, where they exist in parish churches. The difference which such a vault makes can best be seen at St Mary Redcliffe, Bristol, and the entwining effect remains although the ribs themselves in England are again nearly always straight and angular and hard. At Sherborne or Bath [40b], on the other hand, where the vaults are fan-vaults they indeed introduce a note of exotic luxuriance quite in contrast to the angularity of the forms of the church otherwise. But stone vaults are rare in Perpendicular England. Almost without exception English churches of the later Middle Ages have timber roofs instead of stone vaults. These roofs are just as complex as the most elaborate stone vaults, and they are just as angular. They are a triumph of the joiner; the traditions of ship-building behind them have already been referred to. But while they prove the English faith in oak, they also prove negatively a peculiarly

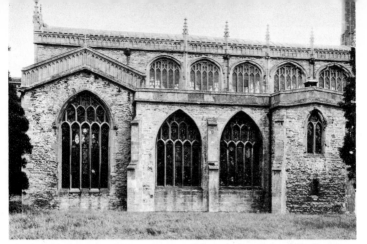

40. THE PERPENDICULAR STYLE: (a) typical tracery at St Cuthbert, Wells, fifteenth century; (b) Bath Abbey, chancel, early sixteenth century.

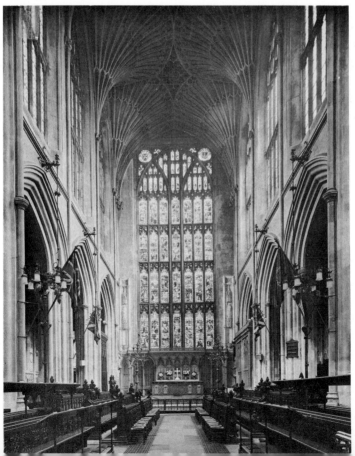

English neglect of space-moulding, one might even say of pulling a building together. Where there is a stone vault, the substance and character of the walls is continued without a break until it achieves itself in the crown of the vault above our heads. The vault rounds off the space, and connects all parts. In England on the other hand what one experiences is one wall, another wall, and beams across. Parts are left as parts, separated from each other.

Now, before the Englishness of the Perpendicular style can be assessed, it must be remembered that a certain amount of what has so far been analysed belongs to the Late Gothic of northern Europe in general rather than to England. The tendency towards large, easily surveyable, wide open spaces in parish churches has its counterpart in the fifteenth-century Netherlands as well as Germany. The Orders of friars had introduced everywhere large preaching spaces plainly and unimaginatively planned. They influenced the parish churches a great deal in all countries, and parish churches are the most typical churches of the Late Middle Ages, because they are the churches of the burghers, the merchants, the bankers, and manufacturers who had the money, the greatest ambitions, and also perhaps the greatest need for redemption. So some of the pride and squareness and matter-of-factness represents the spirit of the age rather than of England.

But it is very much of England all the same, so much so that the Perpendicular style has in its details not even a remote parallel abroad, and so much so that it lasted unchanged for nearly two hundred years. This has been adduced as a sign of conservatism, but it is really also a sign of Englishness. So we can with some confidence now start looking for the peculiar qualities of the Perpendicular in other fields and periods of English art and architecture.

Angularity must be taken first. The flat chancel end of the Perpendicular church has its immediate parallel in the flat-topped tower of the Perpendicular church – something extremely

rare on the Continent, but something that to the foreigner is part and parcel of the English landscape. There are spires of course also, especially of between 1300 and 1350, and especially in such counties as Northamptonshire and Lincolnshire – but the square-topped tower remains England at its most English, also in its absence of demonstrated aspiration, its compromise between vertical and horizontal, and even a certain matter-of-factness. Here, as in the matter-of-factness of Perpendicular space and tracery one may perhaps tentatively look back to the clipped sound of the English monosyllable, to the contrast of *chop* and *costoletta* of which perhaps too much was made in the first chapter of this book. The same compromise between vertical and horizontal also appears in the low-pitched Perpendicular roof and the emphasis on parapets and battlements. It is sufficient to remember the majestic roofs of Late Gothic churches in Germany to feel the fundamental difference.

But it will have been noticed that in the case of *costoletta* and *chop* the comparison is between Italy and England, in the case of high-pitched versus flat or seemingly flat roofs between Germany and England, and it might well be argued that the flat roof is in fact in the Italy of the fifteenth century, at least in secular buildings, as usual as in England. The danger of a comparative geography of art is indeed that by the choice of contrasts facts may just as easily be concealed as revealed. However, if the block-shape of a Perpendicular chancel and of a Florentine *palazzo* are set side by side the validity of the argument is reinforced and not cancelled; for the Florentine *palazzo* ends with a cornice, and the Renaissance *cornicione* has just that organic, fully moulded character which is absent in England and therefore lacking in the English parapet. Flat-roofed Elizabethan houses [59, p. 120] would make this point even more forcibly, but their turn in our context is not yet.

The English unrelieved rectangularity comes out equally convincingly in the plans of churches. There the most telling example is the history of the square-ended chancel. This is,

except for the churches of the reforming Order of the Cistercians in the twelfth century, very unusual in France and Germany.[1] They prefer the rounded end with or without an ambulatory. That gives at once a sense of moulded space, of plasticity, of pulling together. England's preference for walls meeting at right angles and remaining separate from each other and for the enclosed space being like a box, or cube, or block is eminently characteristic of the cathedrals of the classic Gothic century, the thirteenth, of cathedrals such as Lincoln and Salisbury [41]. Wells in the thirteenth century also had a square east end, though it was replaced by a polygonal apse about 1300, at the most anti-rectangular moment in English medieval architecture – a moment of which much will be said later. Ely and Worcester

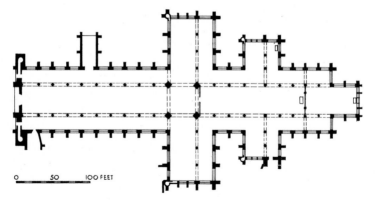

0 50 100 FEET

41. This is a contrast between the compartmented English plan (Salisbury, in this figure) and the compact 'kneaded' French plan (Chartres, 45, p. 101).

acquired a straight chancel in the thirteenth century, and many more examples could easily be given. If Westminster Abbey was designed in 1245 with a rounded chancel end, an ambulatory, and radiating polygonal chapels, that only proves how close Henry III wished to keep to the precedent of Reims and other great French cathedrals.

Even in the Norman style of the twelfth century, England

occasionally voted for straightness.[2] As the Normans had brought
the Norman style from the Continent, their cathedrals and monas-
teries at the beginning had rounded ends and often ambulatories
and radiating chapels. But at Southwell, and in modified forms at
Romsey, at Old Sarum, at Hereford, and others the chancels end
straight, and at Holy Island in Northumberland as early as about
1140 a chancel on the French pattern was replaced by a flat one.

In point of fact this preference in Norman times was a direct
reflection of an Anglo-Saxon preference, and one may hesitate
to regard it too emphatically as Anglo-Saxon rather than more
generally early medieval. Excavations have revealed more and
more straight-ended early medieval churches especially among
those built on a moderate scale.[3] As regards England, rounded
ends occur mostly in the south-east, close to the Channel and
France. In all other parts of England straight ends are usual.[4]
And in perfect accordance with this idiosyncrasy the Anglo-
Saxon designers had a liking for the decoration of external wall
surfaces with unmoulded raised vertical and horizontal strips
rather than pilasters carrying arches or entablatures, and for
arches which are not arches but open triangles, that is have
straight shanks instead of the rounded, plastic, moulded form
of the arch proper. This same mannerism occurs occasionally
even in Mid Gothic, for instance in the north transept of
Hereford Cathedral. The curious habit of arches starting above
the abacus of the column or colonnette or shaft with a straight
vertical piece before turning inwards to form the arch proper – a
habit typical of Westminster Abbey in the thirteenth century
but in evidence in many other places as well – also connects with
this quality.

Closely related to it is that other English preference, the
adding of part to part in plan and elevation. Here again there is
a refusal to mould space, to knead it together, as it were.
Examples of this principle of addition occur in many periods. In
Anglo-Saxon churches for instance very often instead of aisles,
separate oblong chambers are added to the left and right of a

nave which are called *porticus*. They are connected with the nave by doorways rather than arcading, that is, remain isolated instead of contributing to a unified room. Similarly chancel arches in Anglo-Saxon England are as a rule narrow, and tower arches, connecting west towers with naves, are replaced by low doorways. It may not be too far-fetched to refer in this context to the tradition of English friars' churches[5] by which the nave is divided from the chancel by two parallel solid screen-walls forming a passage-way north–south and effectively cutting the total space into three completely separate compartments. And what other country would have conceived anything like the strainer-arches in the crossing of Wells Cathedral [44]? They were necessary to strengthen or strut the tower over the crossing. But if a unified space had been regarded as desirable a system of strengthening piers and flying buttresses could have been devised. The English preferred these huge interlaced ogee struts forming giant arches and leaving nave, crossing, and transepts as isolated spatial units. Indeed even without strainer-arches the transepts of English Gothic cathedrals remain far more isolated than those of France. In France ever since St Denis (1137) and Paris (1161) and certainly since Chartres (1194) [45] the tendency had been to pull the transepts close to the main body of the church so as to avoid any scattering of effects. At Lincoln or Salisbury [41 and 42] the transepts stick out as far as they had done in Norman churches. The French innovation of more closely moulded, unified volume and space is not accepted. That may be called conservatism but it is also a sign of a specifically English dislike of subordination. Parts, to say it once more, remain co-ordinated, added to one another, and in addition box-shaped rather than rounded.

Yet another proof of English co-ordination is the fact that major English churches are entered as a rule by big porches, on the north or south side. In France it is a matter of course that the principal entrance should be by the west portals, usually a group of three, corresponding to nave and aisles. Where such

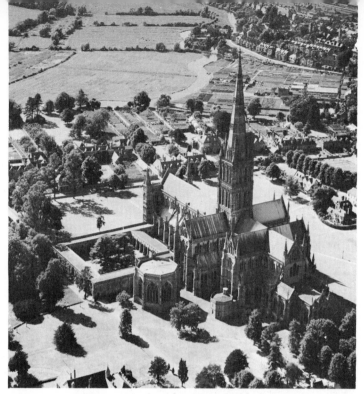

42. COMPARTMENTALISM: Salisbury Cathedral from the air. The typical English thirteenth-century cathedral plan.

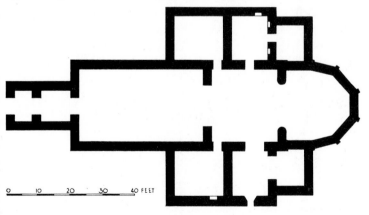

0 10 20 30 40 FEET

43. ANGLO-SAXON COMPARTMENTATION: Deerhurst, Gloucestershire, mainly tenth century.

portals exist in England, such as at Wells and Salisbury, they are
pitifully stunted. The expected scale is regained, however, in the
porches, and the north porch of Wells is in every respect worthy
of that most English of Early English cathedrals. But the porch
is again a compartment, if seen as space, and if seen as volume it
is a block almost like a building brick, which one can put against
the aisle or leave off. The organic logicality of the French west
portals is not understood or aimed at.

And this does not only apply to the portals but to the whole
west fronts. A French façade of the twelfth or thirteenth century
is the logical external expression of the interior: tripartite, as

44. The most fanciful of all examples of enforced compartmentalism
are the strainer-arches of the crossing at Wells Cathedral, *c.* 1340.

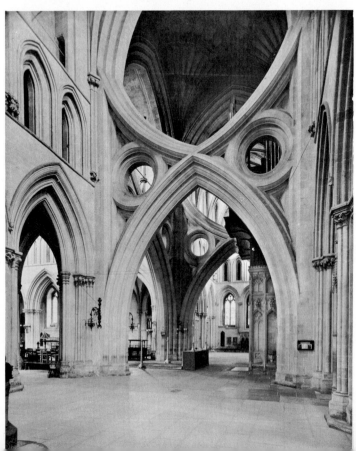

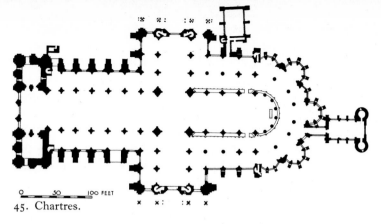

45. Chartres.

there are three parallel spatial streams inside, raised in the middle to represent the height of the nave, and with two towers to stand above the west ends of the lower aisles left and right. The typically English façade is completely different. It is a screen set against the west end of nave and aisles without any organic connexion with it [46]. This screen character has so much that is English that it will keep us exploring for quite a while.

The first characteristic feature is the widening of the façade beyond the outer walls of the aisles. The *locus classicus* for this is Lincoln, where the Norman façade had been of normal width, and in the thirteenth century was converted into a screen. In the same century screen façades were built at Wells and Salisbury. But earlier still some Norman designers had placed west towers outside the aisles instead of in continuation of their lines in order to achieve the desired width at the expense of logic (Old St Paul's Cathedral, London, St Botolph, Colchester).

Illogicality must certainly be listed as an English quality. That will not surprise any of those who start their definition of Englishness from present-day or at least recent cultural experience. The distaste of the English for carrying a thought or a system of thought to its logical extreme is too familiar to need comment. Pope rhymed:

> For forms of government let fools contest;
> That which is best administered is best,

and that remark is as much in praise of illogicality as of reasonableness. There are other aspects to English illogicality – some indeed wholly complimentary – and they will also concern us under the heading of reasonableness as well as under other headings. Examples of illogicality in the architectural field can again be drawn from different ages. Much like the towers outside the lines of the aisles, the English have very early begun to use shafts and arches not separated in the logical and organic Greco-Roman tradition by capitals and abaci. The continuous moulding, as one calls it, in which shaft and arch run into one another

46. ILLOGICALITY: the thirteenth-century façade of Lincoln Cathedral set as a screen against the west ends of nave and aisles without any emphasis on their dimensions. The English delight in surface patterning and also in extreme length and in the grid of uprights and horizontals.

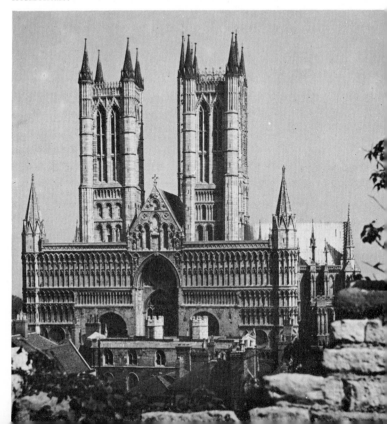

and are thus clearly felt as one line, occurs in the West Country in the twelfth century, e.g. at Malmesbury.[6] They go on along the whole long arcading of the triforium at Wells [47b]. On the Continent they mark the waning of High Gothic clarity (porches of St Urbain at Troyes) and become popular only in the Late Gothic centuries proud of fantasy rather than logic [47c]. In England, as has been shown, their beginnings date back to the Norman era.

During the same era England began to use interlaced arches [47a], again, one feels, as an adverse comment on the initial logic of the arch (e.g. at the chapter-houses of Bristol or Much Wenlock),[7] and a little later even interlaced mouldings of arches, that is an interweaving of the various members of two adjoining arches on the same abacus. In connexion with this one may perhaps also mention – though without exhausting their interest – the blank arcading inside such thirteenth-century churches as Lincoln and Beverley which is conducted in two staggered layers behind each other so that the apexes of the back layer, attached to the wall, are crossed by the colonnettes and arch-springers of the detached front layer. In Lincoln this delight in a playful lopsidedness dictated even the design of the choir vaults. The 'crazy vaults' of Lincoln they have been called in a recent study.[8] Their illogicality is staggering, whatever else they may represent in addition. And they start special English vaulting configurations which in the end lead to lierne patterns so complex in their innumerable crossings of short straight ribs that their origin from the clear, logical French quadripartite rib-vaults is wholly eclipsed. The lines in their rectangular or triangular arrangements seem to be derived rather from types of Anglo-Saxon architectural decoration already mentioned.

Finally, should not also the favourite solution of the English eighteenth-century problem of a church portico and a church tower be listed among instances of illogicality, the solution found by James Gibbs at St Martin-in-the-Fields, where the tower rises above the west end of the nave, but behind the giant portico? It is structurally an uncomfortable solution. The mind

expects the portico to stand in front of the church proper, and the tower with all its weight seems therefore to ride unsupported on the church.

But illogicality is only one aspect of the English screen façade. Another is the usual, yet most peculiar, detailing of these façades. They are regarded as a flat surface to be covered with an over-all pattern of long tiers of blank arches or niches for images. The English pleasure in the overall decoration of a surface must be considered in separation from that in rows of blank arches. One is universal of many periods, the other confined to the Middle Ages.

47. ILLOGICALITY: (a) the intersecting arches of the chapter-house at Much Wenlock, twelfth century; (b) the continuous mouldings (without capitals) of the triforium of Wells Cathedral, *c.* 1210–40; and

The national mania for beautiful surface quality, as Roger Fry calls it in a very different context,[9] is of course an outcome of the national preference for the flat wall. As space is not moulded, so the wall is not, and therefore its enrichment must be on the surface. It appears in the frequent diapering of the thirteenth century (e.g. at Westminster Abbey),[10] in the Anglo-Saxon wall patterns already mentioned, the reredoses, the lierne vaults, and in such an English invention as the type of tracery called reticulated (which can without alteration be interminably extended in all directions [48 a and b]), and so on to the even patterning in the façades of the Houses of Parliament by Sir Charles Barry

(c) the intersecting mouldings of the north porch of Wells Cathedral, *c.* 1235–40.

48. THE ALL-OVER PATTERN: (a) reticulated tracery at New Romney, *c.* 1330; and (b) a typical late medieval reredos (Winchester Cathedral).

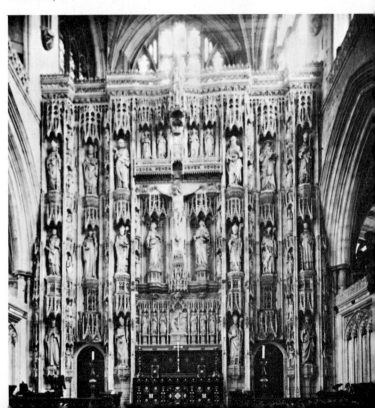

and by the great Pugin, the fanatic of the Gothic Revival and the most fertile of designers of Gothic detail. 'A kind of diapering of the whole' is indeed what Barry called their intention in the detailing of the exterior.[11]

Finally, it might even be said as a postscript that William Morris was destined to become the best designer of the nineteenth century in all Europe at least where flat surfaces are concerned (that is in chintzes, wallpapers, and the like) because he was English and had grown up with a sensitive and intelligent appreciation of English traditions in design. Morris's designs are paraphrases of natural growth. His observation of tree and flower was as close and intense as that of any English landscape painter. But his genius lies in the conversion of these observed data into perfectly fitting surface patterns.

But the surface patterns of the thirteenth-century screen façades have no such direct relation to nature. Their materials are, to repeat it, tiers upon tiers of blank arcading (Lincoln) or of slightly recessed niches (Wells). This motif was such a universal favourite in the English Middle Ages and even later that its Englishness cannot be in doubt. Already the Anglo-Norman style has as one of its characteristics the consistent use of blank arcading, along aisle walls, as along outer walls, and quite frequently such arcading is used in tiers to cover larger areas. The extreme cases are the façade of Castle Acre Priory in Norfolk and the keep at Norwich Castle, but there are plenty of others. The very feeling which they convey is one of interminable length. There is nothing to stop their extension left and right. In this respect, for the thirteenth century the Lincoln front can hardly be beaten, but the front of Ely and especially the west porch (again incidentally pushed against the façade rather than an integral part of it) is also an eloquent example.

And as for the Perpendicular style from which this chapter started, there is nothing more characteristic of it than the consistent, uniform, sometimes exasperating blank panelling of all surfaces with tiers of small blank arches. The interior of the

Gloucester chancel [33a, p. 85] is an early and extreme case, the exterior of Henry VII's chapel at Westminster Abbey a late and extreme case. The style is called Perpendicular, but the grid formed by perpendicular and horizontal lines in all such panelling and in contemporary window tracery as well [40a, p. 93] is really what distinguishes it from all its predecessors. We must here try to look at the two directions first consecutively and then together.

Excessive horizontalism appears as early as the most English Early Anglo-Saxon churches. Monkwearmouth nave is sixty-five feet long, but only nineteen feet wide, Escomb forty-three and a half by fourteen and a half, All Hallows Barking-by-the-Tower in London apparently seventy by twenty-four feet. In most of the Norman cathedrals the same tendency is even more marked. In France, if a nave has twelve bays, that is twelve arches of the arcade between nave and aisles, it is very long (e.g. Cluny Abbey or St Sernin at Toulouse). St Étienne in Caen has only eight bays, Vézelay ten. But Ely and St Albans have thirteen, Winchester and Norwich [49] even fourteen. That lengthening makes a great deal of difference to the eye.

Similarly, if England in the cathedrals of the thirteenth century kept full-size galleries above the arcade [50], whereas France had by then universally abandoned them in favour of shallow low and insignificant triforia, that is not only, as we have seen, a sign of conservatism, but also of horizontalism. Instead of the less and less interrupted *excelsior* of the French churches, at Chartres, Reims, Amiens, St Denis, Beauvais, the English gallery produces a broad and substantial horizontal band between arcade and clerestory and thereby restores a balance between vertical and horizontal. The same effect exactly is obtained by the English thirteenth-century vault. After the 'crazy vaults' of Lincoln choir, the designer of the nave at Lincoln had, about 1235, created a new pattern which at once became English standard. It has a ridge-rib running in an unbroken horizontal all along the crown of the vault and

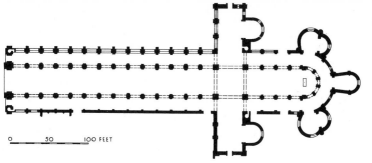

0 50 100 FEET

49. EXCEEDING LENGTH as a typically English quality: Norwich Cathedral.

50. A classic balance achieved of Gothic verticals and English horizontals: Lincoln Cathedral, the nave, *c.* 1210–35. The survival of the gallery, abandoned at the time in France, and the close ribbing of the vault stress the horizontal dimension most effectively.

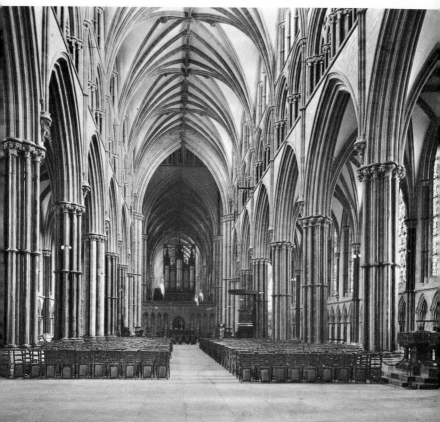

counteracting the transverse divisions of bay from bay and it has tiercerons (soon to be trebled at Exeter) adding so many forms to the vault that it seems to lie heavily on the walls. In France the ribs are a continuation of the tall shafts up the walls, in England the vault is a lid placed on top of the box and decorated with a fine pattern of ribs. The total result is a tremendous upward surge in France, a placid and lovable balance in England.

Again if Germany in her wonderful late medieval parish churches gave the aisles the same height as the nave, that meant that one unified space could flow through the whole breadth of the triple room. England remained faithful to what is called the basilican system, that is lower aisles and a nave with clerestory, and thus kept the three streams of canalized space from west to east more separate and more emphatic in their individual parallel lengths. Finally there is every reason to think in this connexion of the Long Galleries of Tudor and Jacobean houses [51a] – so long sometimes that again one feels they might go on for ever. And do not the terraces of Kensington [51b] and Bayswater with their relentlessly repeated porches also go on for ever?

After the horizontal in isolation, the vertical or perpendicular must be looked at in isolation. However, such an isolation is in fact quite artificial; for the same buildings can often serve to point out horizontalism and verticalism. For example, the Early Anglo-Saxon churches [52a] are equally remarkable for an excess in height as compared with width as for their relation of length to width. Monkwearmouth with its nineteen-foot width is thirty-one feet tall. Or – another, even more impressive example – at Ely [52b] the great corridor-like length of the nave goes with the remorseless rhythm of the tall uninterrupted, mast-like shafts running up the walls in a uniform unbroken rhythm. The same reason underlies the preference of the English in the thirteenth century for shafts of Purbeck marble. The way in which they alternate with limestone shafts [53b] makes one see a group of shafts as a bunch of closely set parallel verticals. To the same

51. EXCESSIVE LENGTH: (a) Combination Room at St John's College, Cambridge, *c.* 1602; and (b) the uniform Georgian brick terraces of English towns: Earl's Terrace, Kensington, London.

date belongs the long slender lancet window [53a] which England and especially the north of England liked better than the French type of classic Gothic window which has several lights below and, above them, a foiled circle or a group of circles of graded sizes. This type of tracery with its verticals rounded off at the end by the more plastic motif of circles is very much the counterpart to the French plan with the rounded chancel, ambulatory, and radiating chapels. The French tracery with foiled circles was introduced into England, it seems, at Westminster Abbey, the most French of the major thirteenth-century churches.[12] It was then, however, it must be admitted, at once fervently accepted at Lincoln, at St Paul's Cathedral, and in diverse other places, and can only be mentioned here as an

52. EXCESSIVE LENGTH AND EXCESSIVE HEIGHT: (a) the seventh- or eight-century church of Escomb; and (b) the Norman nave of Ely Cathedral.

instance of a welcome, most profitable interference with English traditions by the spirit of the age.

The English chapter-house, without any question an English speciality, must also find its place in this context. It is polygonal and not square or oblong, as it ought to be according to the categories laid down here, and it has in its finest examples large windows with the French type of tracery (Westminster, Salisbury, York). It is true that their proportions, made visually effective particularly by means of their palm-tree vaults, mark the chapter-houses as English, but beyond that it would be dangerous to go. Their classicity, the sense of a final achievement which they convey, is the outcome of a synthesis of French and English – the happiest throughout the history of English art.

53. EMPHASIS ON VERTICALS: (a) the lancet windows of the Early English style (Five Sisters, York Minster, *c.* 1250); and (b) the vertical streaking of groups of shaft by the use of Purbeck marble alternating with limestone (Chapel of the Nine Altars, Durham Cathedral, *c.* 1256–75).

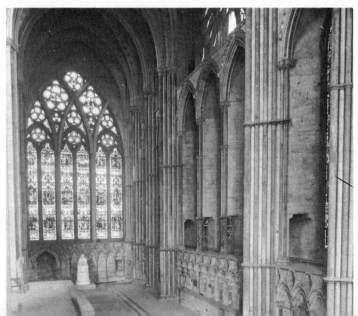

54. **EMPHASIS ON VERTICALS**: the narrowly set vertical struts of English timber-framing (Saffron Walden, house at the corner of Bridge Street and Myddylton Place, *c.* 1500).

After this detour the perpendicular line of English design must be regained, and reference to the perpendicular in the Perpendicular Age will hardly be necessary. As a side issue, however, domestic building in timber during the Late Middle Ages and also the Tudor Age must be mentioned for a moment. The design of timber-framed structures in England [54] is characteristically different from that in France and Germany. The typically English design is one with vertical studs set narrowly between the posts, or, when later on more decoration is desired, with diagonal struts as well. The great masterpieces of German *Fachwerk* at Hildesheim or Goslar or Brunswick and the French examples in Normandy, Burgundy, and so on, are sculpturally much richer in treatment.

Nor is the Perpendicular preference of the English noticeable in architecture only. Professor Frey whose excellent book I have referred to before insists that there are more whole-length portraits in England than anywhere else, from Holbein (for the English had not created the type) to Van Dyck and on to

Reynolds and Gainsborough. It seems doubtful whether one can really go so far – in Venice and Bergamo painters certainly throughout the sixteenth century liked the whole-length too – but the innumerable, slender, very erect young noblemen [55 a and b] and ladies on the walls of country mansions and galleries are without question a striking experience when one travels in England. Was it instinct that made Whistler revive them?

We are on safer ground with sculpture of the thirteenth century [56 a and b]. There – in the façade of Wells with its more

55. EMPHASIS ON VERTICALS in English painting: (a) a typical Tudor portrait (Hans Eworth, *Henry Stuart Lord Darnley and his brother*, Windsor Castle, 1563); and (b) a typical Reynolds portrait (*George John Viscount Althorp*, Althorp, 1767).

than a hundred statues, or with the Annunciation in the chapter-house of Westminster Abbey – figures are bafflingly elongated and draperies stress this verticalism by their long, sharply cut, perpendicular folds. Contemporary French sculpture is fuller and again somehow more kneaded and less cut. Any comparison of the angels in the triforium of the transepts of Westminster Abbey with their prototypes, the angels of Reims, will show that. And this perpendicularism pleased the English so much that they continued with it, and in their most national branch of late medieval carving, their alabaster altars and panels [57], the figures are long, lean, thin-faced, and sparing in their

56. EMPHASIS ON VERTICALS (a and b) in the thirteenth-century sculpture of Wells Cathedral.

57. EMPHASIS ON VERTICALS in the figures on English alabaster panels of the fourteenth and fifteenth centuries. Victoria and Albert Museum, London. Crown copyright.

movements – unmistakably types you see about in town and country in England.

The favourite type of figure of the first Anglo-Norman school of manuscript illumination is in fact almost a caricature of this English type. In the Psalter of St Alban [58] and related manuscripts they stand in groups, gaunt, stiff, and with motionless features – extraordinarily and oddly similar to many of the Elizabethan funeral monuments where husband and wife or two wives lie similarly long and stiff and motionless side by side. That may in Elizabethan sculpture often be sheer incompetence. It may also to a certain extent be a convention of that age all over Europe, the convention of Mannerism, with its belief in elongation and enforced restraint – but it is all the same very English too.

Otherwise the parallelism of these gaunt figures with Elizabethan architecture could not be so close – an architectural style, wholly English, however much inspiration from France and the Netherlands may have set it moving. The Elizabethan style as

illustrated by say Longleat or Burghley has a good solid hard core of Perpendicular tradition – English conservatism, as it might well be called. Windows are tall and wide and of many lights. It is true that they have lost the last vestiges of curves which still existed in Perpendicular tracery, but the proportions are the same and, what is even more important, they impress (exactly as in the case of Perpendicular windows) the character of a grid of verticals and horizontals on the whole façade.

It is indeed the conceit of the grid that unites the two English dimensions and allows them to exist together. Of all Elizabethan

58. EMPHASIS ON VERTICALS in English painting: Psalter of St Alban, early twelfth century (Hildesheim, Germany).

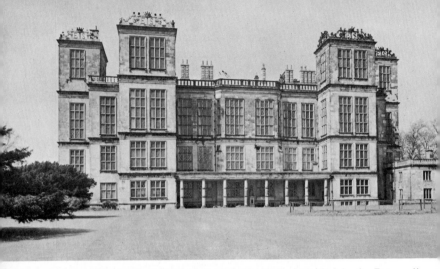

59. The grid of verticals and horizontals, heralded in the Perpendicular style and carried to the extreme in houses such as Hardwick Hall, Derbyshire, of 1590–7.

houses none is perhaps more undilutedly English than Hardwick Hall [59]. Here the plan is like that of a thirteenth-century cathedral – the outcome of rectangle or square added to rectangle or square. The elevation is of blocks pushed against blocks, and the roofs are unrelievedly flat. That alone creates a totally different *ensemble* than for instance in the French country-house, where big pavilion roofs remained the crowning motif down to 1660 and beyond. The parts raised higher at Hardwick are strikingly like Perpendicular towers. Finally the large windows form a consistent grid.

This conceit of the grid is one underlying much of contemporary architecture. It should have made the acceptance of the twentieth-century style easy in England. Any comparison between a modern building and Hardwick will show the basic affinity. Yet the style, after a prehistory more eventful in England than anywhere else, had to emigrate. The reasons are not far to seek: conservatism and that distaste of revolution which was hailed in earlier pages of this book. Yet, if the style of the grid

and of no mouldings has now acclimatized itself so successfully, one may perhaps attribute this belated success to an instinctive recourse to the Perpendicular and Elizabethan past.

Once this English notion of the grid has been isolated, it is easily recognized also in more unexpected places. What else for instance is the Circus at Bath [60], designed by John Wood the Elder in 1754? The architecture is classical, columns superimposed on each other in three tiers, but the columns and the friezes which they carry are a grid all the same. So are the long stretches of completely unadorned terraces of Georgian brick houses [51b, p. 111] with nothing but evenly cut-in, unmoulded, unenriched window openings which one finds everywhere, and nowhere more consistently than in Gower Street.

60. The Circus at Bath, by John Wood the Elder, 1754–8, though designed with superimposed classical orders, is yet almost as much an all-over grid as Hardwick.

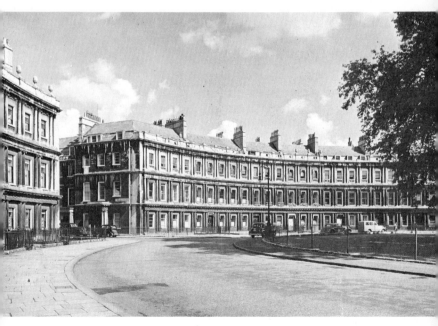

And if the English liked to build their country-houses and palaces in the taste of Palladio's mid-sixteenth-century villas round Vicenza and Padua – one can say much about that which has nothing to do with our present subject, and more will indeed be said about various aspects of English Palladianism later [34 a and b, p. 86, and 89, p. 175] – but if the English took Palladio as their guiding star rather than the Baroque and Rococo, can a reason for this not also be found in the English qualities under discussion now? Houses like Holkham, Wentworth Woodhouse, Prior Park Bath, Croome Court, and so on all over England are a new, post-Renaissance version of the English ideal of the square block,[13] of the curveless verticals and horizontals, of *chop* and not *costoletta*, and also, to widen the interpretation, of rationalism.

It will surely not be denied that rationalism and often, to use a more homely term, reasonableness lies behind Palladian as well as Perpendicular architecture. It lies behind much else in English architecture too, even the noblest of its incarnations, the Early English cathedral. If one compares Lincoln with Chartres, begun within five years or less of one another, there is, to reiterate it, nothing more striking than the contrast between French verticalism and English balance of directions – or indecision, or compromise. How the English designer contrived to stress his horizontals sufficiently to counteract the many slender perpendiculars of his biscuit-coloured and grey shafts, has been demonstrated. What by such means Lincoln lacks in enthusiasm and, to use the untranslatable Italian term, *slancio*, it gains in mellow humanity, in sheer happiness. Detail is opulent without being luxuriant as in the Decorated style to follow, and it has never yet the dryness of much of the detail of the Perpendicular style which was to follow the Decorated after only two generations. In the Perpendicular style the rational aspects of the English Middle Ages culminate, the thirteenth century's generous ideals having been run down to earth – just as in the Palladian style the rational aspects of the pre-industrial period of modern England culminate.

Now rationalism, or, in everyday language, sensible behaviour, is decidedly a middle-class ideal. Hence it is not surprising to find it in command in the Late Middle Ages. There is nothing new in viewing the later fourteenth and the fifteenth centuries in terms of a predominance of the merchant. This is so everywhere on the Continent and especially so in England. As early as about 1290 the son of a Ludlow clothier built for himself Stokesay Castle in Shropshire, one of the first in England to be described rather as a fortified manor-house than a castle, and about 1350 Penshurst was built by a London merchant. There are plenty of other cases.

It should hardly be necessary to add that class alone does not suffice to explain the fifteenth-century style in architecture, or else S. Lorenzo in Florence and St Lorenz in Nuremberg would look like St Laurence in Ludlow. Class is only one contributing factor, though it made itself felt with special determination in England.

A connexion between the middle class as carrier of rationalism and the Palladian style in England seems less convincing at first, although the importance of middle-class ideals in English literature of the same years is a universally accepted fact to which reference has been made earlier.

It would be tempting to stress the fact now that perhaps the earliest and certainly one of the most influential of the major Palladian mansions of England – Wanstead House in Essex by Colen Campbell [34a, p. 86][14] – was built for a banker. However, the other equally influential and exactly contemporary house by the same architect was Lord Burlington's town-house in Piccadilly, and Richard Boyle, third Earl of Burlington and fourth Earl of Cork, was certainly a member of a family of long-standing aristocratic tradition. The majority of the Palladian mansions were built for the aristocracy. But in this there can appear a contradiction only to those who regard the English aristocracy as if it were of the same kind as the French or German. In fact, however, transition from middle to upper class was far more fluid in

England than anywhere else. Voltaire in 1731 commented on the fact that younger sons, in England, go into trade.[15] The custom lives on, happily and sanely, to this day. If one takes *Whitaker's Almanack* and checks on the dates of creation of the English titles existing today, the result is approximately this: of about 390 dukes, marquesses, earls, and viscounts – only about 20 date from before 1600, but about 210 from after 1800. Of about 500 baronies over 400 date from after 1800, and only about 30 from before 1600.

So if reasonableness is primarily a middle-class ideal and so much in English art and English culture in general, and on all class-levels, is so eminently reasonable, that is not a contradiction. How much of what is considered typical of the English can be looked at from the point of view of reasonableness needs no comment. Reasonableness can be the platitudinous pomposity of Dr Johnson in the eighteenth century or the accomplished urbanity of John of Salisbury in the thirteenth. A sign of reasonableness is the early growth of government by Parliament from the fourteenth century, or the fewness of parliamentary parties today, and their lack of ferocity in combating each other. There are on the other hand many religious sects, but religion is another matter. Many parties are an obstacle to a sensible administration, sects are a private affair not chosen for reasons of usefulness. There is here, it seems, an important clue to the mystery of the interaction of uniformity and individualism in England.

Reasonable and profitable was the Elizabethan Settlement already considered in another connexion, reasonable and profitable the policy of religious tolerance and of hospitality to foreigners who desired or needed a new home. The list from Polydore Vergil and Vermuyden to Prince Albert and Panizzi, and – to return to art – from Holbein and Van Dyck to Rossetti and Whistler is a long one. They all came with their own contributions and received as much as they gave, though neither Rossetti's nor Whistler's contribution could be included in the

category of rationalism with which we are concerned at the moment.

But rationalism remains the commanding power. To conclude this chapter, three first pages of English essays or books may be quoted.

Francis Bacon's *Essay of Building* has as its first sentence:

Houses are built to live in and not to look on; therefore let use be preferred before uniformity, except when both may be had. Leave the fabric of houses for beauty only to the enchanted palaces of the poets, who build them with small cost.

And Chapter One of Hogarth's *Analysis of Beauty*, in spite of the flamboyance of his paint and in spite of his enthusiasm for the serpentine, that is the Rococo, line, starts like this:

Fitness of the parts to the design for which every individual thing is formed, either by art or nature, is first to be considered, as it is of the greatest consequence to the beauty of the whole.

Hogarth goes on to illustrate this by the size and shape of chairs, of pillars and arches, and after a few sentences arrives at this:

In shipbuilding, the dimensions of every part are confined and regulated by fitness for sailing. When a vessel sails well, the sailors . . . call her a beauty; the two ideas have such a connexion.

And even if one takes Pugin, he writes, in spite of his Neo-Gothic and his Catholic fanaticism, on the first page of his *True Principles of Pointed or Christian Architecture*:

The two great rules for design are these: First that there should be no features about a building which are not necessary for convenience, construction, or propriety; second that all ornament should consist of enrichment of the essential construction of the building.

Pugin hated classical design as pagan and therefore unworthy. Yet if one looks for the best illustration of Pugin's rules of good

61. REASONABLENESS AND GOOD SENSE in English eighteenth-century design: (a) an Early Georgian chair (Victoria and Albert Museum, London. Crown copyright); and (b) early-nineteenth-century Wedgwood dinner-ware (Wedgwood Museum, Barlaston). The plates of the catalogue from which illustration 61b is taken were engraved by William Blake.

design, one would have to go to the same English eighteenth-century chairs [61a] which Hogarth had used to illustrate functional beauty, because they are so much less arbitrary than those of the French Rococo, and to the shapes of Wedgwood dinner- and tea-sets [61b]. As regards chairs one should of course not go to Chippendale, although his name is the most famous amongst the craftsmen of England, because his most admirable *tours de force* are rather cases of a successful interference of the spirit of the Rococo with traditional Englishness than of Englishness as such. One should rather look at less *outré* chairs. In them the same synthesis of elegance with reasonable principles appears as in the shapes of Wedgwood pottery. There is about Wedgwood's late-eighteenth-century teapots and cups a quality of undated rightness not transcended by anything designed in our century. One buys them today, just as one can see them illustrated in Wedgwood's catalogues as far back as 1800 and before.

Two illustrations of plates from a catalogue of 1816 are accessible in a book in which one would least expect to find them: Mr Geoffrey Keynes's *Blake Studies* of 1949. For William Blake of all artists engraved these plates. He had to; for he was never able to make a success of his art. 'We are a commercial people,' wrote Hogarth in his memorandum against academies.[16] Blake saw his Albion defaced by furnaces and looms 'round which the Fiends of Commerce smile'; Francis Bacon to him was the man who 'has ruined England',[17] Reynolds was 'this Man hired to depress Art'.[18]

Blake was the most fanatical enemy in English art of those qualities which have so far been placed in the foreground, observation on the one hand, rationalism on the other. With Blake, and at the same time with the Decorated style in medieval architecture, we must next try to explore the other pole – the irrational elements in British art.

5 BLAKE AND THE FLAMING LINE

Blake knew of the importance of polarities. Only he did not call them polarities, he called them Contraries:

Without Contraries is no progression. Attraction and Repulsion, Reason and Energy, Love and Hate, are necessary to Human existence.[1]

But for a full understanding of those qualities of Englishness which culminate in Blake and also for a more direct link with the subject-matter of the preceding chapter it is advisable not to start with his work and views immediately but to lead up to them gradually from the outstanding example in England of progression by contraries – the development of architecture from about 1290 to about 1350. What 1350 stands for has been explained. The Perpendicular style is reasonable, angular, matter-of-fact, repetitive, and impressive by its spaciousness and clarity. The style that went before, the Decorated style, seems in every respect the opposite of the Perpendicular. Yet it is as utterly English as the Perpendicular. It has no contemporary parallels whatsoever on the Continent, though, oddly enough, parallels (or repercussions) especially in Germany, starting fifty years later. But that mystery does not concern this book. What concerns it is the distinctive qualities of English architecture of 1290–1350, as

exhibited in such buildings as Bristol Cathedral, the Octagon and the Lady Chapel at Ely, the east end of Wells Cathedral, and innumerable funeral monuments, none more fascinating than the tomb of Edward II at Gloucester and the Percy tomb at Beverley [62].

Now fascinating is the one word one would never use to describe Perpendicular architecture. One may admire it, one may respect it – but fascination is a term slightly ambiguous, slightly questionable, and Perpendicular is downright and direct. Decorated is perverse, capricious, wilful, illogical, and unpredictable. It is unreasonable, where Perpendicular is reasonable.[2]

62. THE UNDULATING LINE can convey luxuriance. Detail from the Percy tomb at Beverley, *c.* 1345.

Decorated must be understood as a reaction against the noble clarity of the Early English style of Lincoln and Salisbury. There, as we have seen, in a clear and English way, part had been added to part, each carrying on its free yet measured existence, the nave, the aisles, the crossing, the transepts, the chancel. Arches were resiliently rising to the point where they achieve themselves, capitals were either moulded in neatly defined parts or enriched by that springy kind of stylized foliage which we call still-leaf or later by equally crisp naturalistic foliage. English architecture had been as superb in its own way as Chartres and Reims.

Now all this was abandoned, for reasons it seems of a nausea of perfection. Windows instead of being noble groups of lancets or possessing the classic French tracery with simple foiled circles develop the weirdest tracery, shapes like the leaves of trees, like daggers, like kidneys, like bladders, bounded by lines like flames or like waves [63a]. Flowing tracery is indeed what this type of decoration is called. Nowhere is it more fantastical than in the parish churches of East Anglia and Lincolnshire. The foliage of capitals turns away from nature, and the resulting forms are vaguely reminiscent of seaweed (though definitely not imitations of it) [63b]; bossy, nobbly – and again undulating in their surfaces.

And now, if one turns from architecture to the human figure, exactly the same qualities will be found, only emotionally more explicit. Here also, in those years, England was in the European vanguard. Perhaps her most famous speciality on the Continent was the art of embroidering – what was known simply as *Opus Anglicanum*, pieces such as the Syon Cope and the Butler Bowdon Cope at the Victoria and Albert Museum and as the others in such distant places as Bologna and Ascoli, Toledo and Madrid, and Uppsala. But English illumination was of the same high order and, at least by the illuminators themselves in such countries as France and Germany, equally appreciated.[3] To mention only a few of the outstanding manuscripts of about

63. THE UNDULATING LINE: (a) flowing tracery of the early four-teenth century on the west front of York Minster; and (b) wilful curves and counter-curves surrounding the north portal of St Mary Redcliffe, Bristol, *c.* 1320–30.

1300, there are the Arundel Psalter, Queen Mary's Psalter, and the Ormesby and Gorleston Psalters. So far we have only looked at these marginally – literally marginally: at the babwyneries in their margins, these amazingly lively little scenes of everyday life or caricature. Now we must examine the centres of the pages, the scenes from Holy Writ which seem to coexist as naturally with the grotesques as tragedy and clowning coexist in Shakespeare's plays [64]. These pages are indeed exquisite, very much in the sense in which Decorated architecture is exquisite. The actors in the sacred stories are long and slender, their heads are exceedingly small, their bodies attenuated and swaying, their outlines sinuous. There are no real backgrounds, just a diapering perhaps, and no clearly directed actions. This is a world of disembodied bodies, almost spectres, moving weightlessly, or one could say with Blake: 'silently, invisibly', with inscrutable expressions in their oddly boneless faces. Yet these figures can express passion – a passion not displayed in action, but rather suffered, a passion distorting body and face in those very curves which at other times seem to express no more than a sophisticated courtly elegance. The line of the Decorated style can be flowing, but it can also be flaming – elegant or tense. We are face to face here with a phenomenon with which one is more familiar in cases such as Greco's or other Mannerist painters'. There also one can seldom escape a disquieting sense of ambiguity between what seems the self-effacing experience of the mystic and what may be no more than a highly self-conscious kind of ritual ballet.

With this clarified vision of the Decorated style established, it can now for the first time in these chapters be demonstrated how useful the notion of polarities or contraries proves in action. So far the Decorated style has appeared as in everything a contrast to the Perpendicular. But for a complete picture of Englishness in art one needs indeed both styles together. The question which arises is what the two styles have in common. The answer is that both styles are anti-corporeal or disembodied, in the sense of a negation of the swelling rotundity of the body.

64. THE UNDULATING LINE can serve the greatest intensity of expression. Crucifixion from the Psalter of Robert de l'Isle, *c.* 1300. British Museum. The figures are excessively elongated, swaying, with curved outlines and folds of their draperies. No firm modelling of the bodies.

Perpendicular denies it with angular plans, angular towers, long, thin, wiry, sinewy lines, Decorated also with long, also with thin, but with flaming or flowing lines. But both are unfleshly, both linear. Roger Fry[4] says, indeed, of the English painters of the last two hundred years that 'their art is primarily linear, . . . and non-plastic'.

Other phases of English art deny the body by yet other means. Professor Wormald and others have in the last years drawn attention to the characteristics of English illumination in the tenth and eleventh centuries.[5] What are they? A 'scintillating' line, a denial of the frame so that 'figures can escape where they will, on the page' (these are Professor Wormald's words), 'odd scratches and marks' (this on the other hand is what Reynolds said of Gainsborough),[6] and colour used for the line-work only instead of the solid body colour of contemporary, that is Ottonian, Germany for instance. The source of this inspired draughtsmanship is, as we have seen before, the Utrecht Psalter [37a, p. 88] of *c.* 830 which happened to belong to Canterbury Cathedral, that is: it is Carolingian, continental, of a much earlier age, and initially Oriental. But origin matters less than that it became an English speciality. Again, at Winchester, where from about 970 onwards illumination flourished, the draperies are drawn in wild lightning zigzags, and the thick lush frames in flaming, scalloped leaf shapes. Here also the sources are Carolingian, but the development in England is much more consistently linear.

The Normans, when they came, did away with all that [58, p. 119]. Their style of stiff bolt-upright figures, as mentioned before, is a kind of 'Perpendicular' reaction to these 'Decorated' excesses. But it, in its turn, was soon followed by a milder, gentler style of illumination, the style of the Lambeth Bible [65] and the great Winchester Bible of about 1160 and after, and there the figures are slender and bounded by shallow tender curves.[7] What goes through all these transformations of English medieval painting is an unconcern with the solid body and a

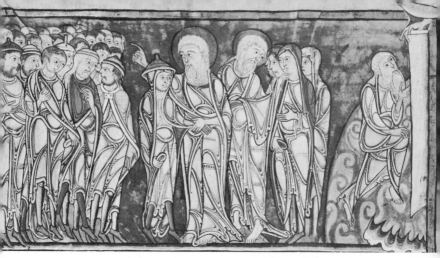

65. THE FLOWING LINE in English mid-twelfth-century illumination, a reaction against the stiff verticalism of the style of the Psalter of St Alban (see illustration 58, p. 119). The Lambeth Bible, Lambeth Palace, London.

66. THE CELTIC SOURCES OF ENGLISH LINEARISM, a page from The Book of Kells (eighth century, Trinity College, Dublin).

watchful interest in the life of line instead – zigzag at first, undulating later; violent at first, tender later – but always line, not body.

Once that has been established one can without fear trace it back to the illuminated manuscripts of the seventh and eighth centuries in Northumberland as well as Ireland [66], and perhaps, though more hesitatingly, to the style of the Celtic Britons in England in the Iron Age, the spiral scrolls decorating the Desborough Mirror [67] at the British Museum and the shield from the Thames in the same collection.[8] Manuscripts such as the Book of Durrow or the Gospels of St Chad, with their fabulous interlacing of ribbons and scrolls and their distortion of the human body into a flat board to place a diaper pattern on

67. THE CELTIC SOURCES OF ENGLISH LINEARISM: the Desborough Mirror, first century A.D. British Museum, London.

68. LINE (OR RATHER BANDS) AND NOT BODY in English illumination of about 700. Gospels of St Chad, Lichfield Cathedral. Victoria and Albert Museum, London. Crown copyright.

(Durrow), or into a pattern of intertwined bands (Chad [68])
have certainly the anti-corporeal flatness noticed throughout
English architecture and the anti-corporeal intricacies of line
noticed in some English architecture and in much later illu-
mination.

The English are not a sculptural nation. The majority of
Norman decoration is abstract, not figural. Most large-scale
English medieval sculpture is of a quality not comparable for
the thirteenth century with France, for the fourteenth and
fifteenth with Germany, even allowing for the ruthless destruc-
tion of so many images by Puritans in the ages of Henry VIII
and Cromwell – which in itself of course were anti-sculptural
demonstrations. One ought also to remember that for funeral

monuments, in the later Middle Ages, the English developed an enthusiasm for brasses – that is not sculpture at all but engraving.

Then, when it comes to Elizabethan and Jacobean sculpture, most of that was the work of foreigners and little of it is of good quality. Mostly these funeral monuments and mantelpieces are indeed, whether done by Englishmen or Flemings, amazingly poor. And who is the most famous English sculptor of later ages? 'If we are suddenly asked this question,' says Roger Fry,[9] 'there is no name of sufficient resonance to rise instantly to our minds.' The most probable name to be suggested is John Flaxman. He, as the *Gentleman's Magazine* wrote at his death in 1826, 'acquired a higher reputation than any artist of our country excepting Sir Christopher Wren and Sir Joshua Reynolds'. Ary Scheffer, the eminently popular, sentimental French painter of the 1830s and later, said that every young artist has his Flaxman as he has his Dürer, Rembrandt, and Goya.[10] But then 'his Flaxman' does of course not refer to sculpture at all, but to Flaxman's outline drawings to Homer [72a, p. 148], Dante, and others, with their sensitive, gentle undulations. His monuments are certainly not great sculpture, though the most intimate of them are very attractive.[11]

However, two things ought to be remembered before any final statement is made about English character and the art of sculpture. The first is that only fifty years before Flaxman the English were certainly able, if not to create sculpture of the highest order, at least to appreciate it. Roubiliac and Rysbrack were not short of clients, and their monuments as well as portrait busts are as accomplished, as solid, and as certain of their third dimension as any on the Continent. As they are, especially Roubiliac's, also violently dramatic, that is Baroque, and in this respect (according to the thesis of this book) un-English, their appreciation poses a problem. It is a problem met on similar terms earlier on in the case of Hogarth, an interference of the spirit of the Baroque and Rococo with the prevalent English spirit, and it can only be solved satisfactorily if one remembers

the profound changes of national character brought about in the mid nineteenth century. Of these much will have to be said at a later stage.

Is an equally profound change taking place now? Or how can one explain the phenomenon of Mr Henry Moore? I do not see the signs of such a profound change (the so-called new Elizabethan Age), and hasten therefore to declare that Henry Moore's greatness as a twentieth-century sculptor indeed contradicts all that I have put forward in this chapter. If the English are an unsculptural nation, if it is true that at no time in the past have they produced work, at least on any but a very small scale, that would emulate that of France, Italy, and Germany, how can it be that the greatest sculptor now alive should be English (and, on top of that, unmixed Yorkshire), and that other younger English sculptors are universally accepted as among the most important of Europe? One valuable lesson can be drawn from this undeniable fact. The individual may at any moment widen the possibilities of a country, and in future critics and scholars will have to puzzle over a new polarity. The case is not unique. Turner, to a certain extent, is another such lucky freak, English in much, but un-English in some essentials. And when it comes to Shakespeare, he would, as has already been said, by the sheer dimensions of his genius burst any scheme either of historical period or of national style.

However, though the consideration of such exceptions is profitable and indeed necessary, it yet remains fundamentally true that the English have nothing of the Italian, the Mediterranean confidence in the body. It may be said that Puritanism has driven it out – but Puritanism, although it helped to shape the English was also shaped by the English, and its persistence in Victorian guise is certainly English. The nude, for instance, in spite of William Etty, has been a rarity in English painting over centuries – and is now. One need only compare in one's mind the Royal Academy and the Paris Salon. This is also an angle under which the absence of Baroque art in England can be seen.

The Baroque, as practised in Italy and later in southern Germany and Austria, is so impregnated with a sense of body that one can never get away from it: curving interiors, bulging façades, crowds of painted and stucco bodies in the ceilings, vast muscular saints in the altars, half-naked hermaphrodite angels exposing their long limbs. England has little of that. Even Vanbrugh's Baroque is not moulded, kneadable, as it were, but in angular masses, in cyclopic cubes. And if one takes Hogarth with all his liking of a fetching semi-nudity and of rich, fluid Baroque paint – what is it he proclaimed as his panacea? The Line of Beauty, the elegant double-curved line, the ogee-line of the Decorated style, the *linea serpentinata* of the Italian Mannerists.

Yet it would be over-simplification to demonstrate the eternal Anglo-Italian contrast purely as one of two-dimensional and three-dimensional. For the Decorated style in English architecture, and that aspect of it has so far, quite unjustifiably, been left out of account, is a most fascinatingly spatial style. In the Early English and the Perpendicular styles space-cubes are put together, but at Bristol Cathedral, the east end of Wells, and the crossing of Ely space flows in all directions, undulates, one might say with a little poetic licence, as the elements of decoration undulate.[12] This treatment of space comes close to that in German churches from the late fourteenth to the early sixteenth century, but it is fundamentally different from the treatment of space in Italy. In Italy space always tends to be what fills a solid enclosure. Volume is felt before space. Hence the delight in the dome, and the perseverance in the use of apses and round-headed arches. For the semicircle is a self-sufficient curve. It does not point beyond itself as does the Gothic arch. And if instead of this unpermissible comparison a comparison has been allowed just now between the German Late Gothic style and the English Decorated, it must be remembered that all through the years of the German Late Gothic with its spatial adventures, England was steadfastly Perpendicular, that the Decorated was

no more than a brief phase of reaction against the clarity of the Early English, that its full spatial possibilities were explored in only a few buildings – hardly more than the three just mentioned – and, in addition, that the Decorated has nothing like the soaring heights of the German hall churches, and on the other hand nothing like the solid, powerful enclosing walls and the mighty roofs of these churches. There always remains something brittle or tenuous in the architecture of the Decorated style.

This characteristic quality has so far been studied here only in medieval art. But it can also, without effort, be seen in the graceful stance and the elegant frailty of Van Dyck's English portraits, so much less substantial than those he painted at Antwerp and in Italy, and even more in Gainsborough's portraits. So far in these chapters Reynolds has been the almost exclusive representative of English portraiture – at the expense of Gainsborough, who was the more painterly painter of the two and therefore predestined rather to quarrel with the Royal Academy than to become its president. What raises his portraits to the height of the best painted anywhere in Europe in the eighteenth century is three qualities, all equally English: their psychological understanding, their feathery lightness of touch, and their sympathetic setting in landscape [69]. Gainsborough was as intelligent an observer of human beings as Reynolds and as sensitive as Reynolds to the social conventions which their English sitters wished to see expressed more insistently than details of features. But Gainsborough, by refusing to accept Reynolds's doctrine of the elevated portrait strikes one often as closer to reality and indeed more veracious. More outspoken he certainly was. The comparison between the two portraits of Mrs Siddons has already been made to illustrate this point. Many other comparisons would enforce it.

Gainsborough's technique has been admirably characterized by Reynolds[13] as 'hatching', 'unfinished', and – see above – 'odd scratches and marks'. What these expressions refer to is

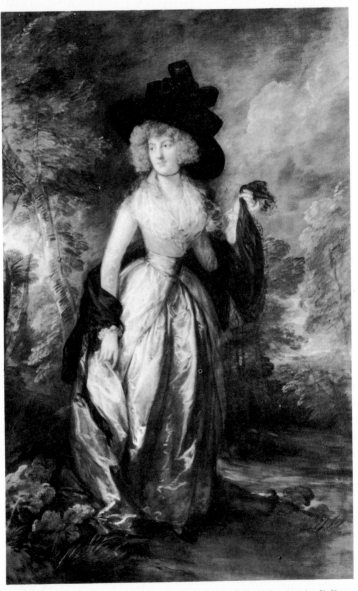

69. THE LINEAR HATCHING TECHNIQUE of Gainsborough. *Juliana Lady Petre*, 1788. Huntingdon Foundation, San Marisco, California.

Gainsborough's ingenious and original reduction of the volume of a figure and the space of a landscape to surface run over rapidly with fine brushes – a sketching technique applied to oil-paint. The elegance aspired to by the sitters, or at least most of the lady and many of the gentleman sitters, is gained by re-creating them into images of immaterial lightness. There is never obtrusive physical presence (understatement again, one may say), nor are there pure, glowing, intense colours.

Elegance, soft colouring, soft attenuated curves, as they characterize Gainsborough in painting, characterize in architecture the work of Robert Adam [70]. His interiors are one of the great European achievements of the eighteenth century, delicate, transparent, pastel-shaded, and often with a preference for the gentle segmental arch in plan or elevation over the more determined semicircular. But in introducing Robert Adam two restrictive comments are necessary. One is that he represents to a considerable degree a trend equally important on the Continent, a kind of *menshevik* revolution against the exuberance and the artificiality of the Late Baroque and Rococo. Its continental beacons are Gabriel's Petit Trianon, Anton Raphael Mengs's ceiling painting of *Parnassus*, Greuze's sentimental and to a limited degree sincere scenes of rustic life, and (as Reynolds put it) 'the interesting simplicity and elegance of [Gainsborough's] little ordinary beggar-children'. So here once more *Zeitgeist* and Englishness co-operate.

But, and this is the second comment which the appearance of Robert Adam in this book demands, can Robert Adam's style be at all discussed in conjunction with Englishness? He was Scottish, his father had been an architect at Edinburgh, he grew up in Scotland, and decided to live in London only at the age of twenty-nine and after over three years in Italy. Nor does it seem justifiable to describe his style as the result of London influence.[14] The fact must be faced that in the case of Adam – who after all is without doubt the most famous Scottish architect and one of the most famous of all architects of Great Britain – no

distinction can be made between Scottish and English qualities. This does not mean that there are no specifically Scottish qualities, nor even that they are operative to so limited a degree as say East Anglian qualities or West Country qualities. It is true that Gainsborough, Crome, Constable, Cotman all were East Anglian, and that a generally Dutch character of landscape seems to account for this Dutch genius for landscape. But as a whole regional qualities do not play the part they play in Germany and have played in the past in Italy. The reason is simple. Germany and Italy are the late-comers in Europe as united nations. Their civilizations grew regionally and remained

70. THE TENDER CURVES of Robert Adam's interiors. Osterley Park, Middlesex, c. 1766–73. Crown copyright.

regional. The French Romanesque style in architecture can only be understood regionally. Then came Philip Augustus, early in the thirteenth century, and united France, and from that time regional specialities decreased and Frenchness increased. It may still be illuminating to see Poussin as a Norman and Puget as a Southerner from the Italian border, to remember that Watteau is near-Flemish and that the Rococo was created by men from the Italian border or with Italian connexions. In England this point of view is not profitable, and it is only occasionally profitable in Scotland.

It is easy to recognize Scottishness in the Scottish castle of the seventeenth century, and the profound difference between, say, Glamis Castle and Bolsover is not only one of defensive and civil architecture.[15] The extreme contrast of soaring sheer walls and the most unexpected crustaceous projections on top is the best introduction possible to the Scottish polarity. The Scottish delight in sheer height of a block of building – quite absent in England – may well have predisposed the Scots towards their towering blocks of flats, and the Scottish delight in the fantastical suddenly emerged, utterly unexpectedly, about 1890 in the paintings of the group of Glasgow artists known at the time as the Glasgow boys. Scottishness can also be detected in the peculiar freshness of Raeburn which distinguishes his portraits as much from Reynolds's as from Romney's, Scottishness in the Ossianic work of the Runcimans and John Brown. And the great Scottish polarity appears emphatically in the contrast between the sobriety and solidity of mid- and late-nineteenth-century architecture in Scotland, always distrustful of the fulsomeness of the English High Victorian style, and the fantastical developments of the Scottish Baronial in the hands of that Scottish genius, Charles Rennie Mackintosh. As profitable to him as the castles and fortified houses were the unpredictable curves of Celtic illumination and metalcraft. The feeling of a capacity to draw on an obscure store of Celtic fantasy and magic may even (though only in conjunction with a training in the office of

Lutyens) account for the surprising qualities of Mr Basil Spence's Coventry Cathedral.

But to return from the zigzags of Coventry details and the curves of Mackintosh's details to the even flow of the gentler curves of Adam, Reynolds, and Gainsborough, the curves that are universally English and universally late-eighteenth-century, one can see them to perfection in the products of Josiah Wedgwood's Etruria Works [61b, p. 126, and 71a], products as famous all over Europe as was Adam's architecture. They were incidentally also extremely English in being early examples of

71. THE TENDER CURVES of (a) eighteenth-century Wedgwood ware, compared with (b) the robustness of Greek fifth-century vases. Wedgwood Museum, Etruria, and British Museum, London.

quantity-production. That has already been mentioned in another context. Here all that is needed is a comparison between a Wedgwood vase and a genuine Athenian fifth-century vase (Wedgwood called his factory Etruria, because it was believed then that Greek vases were Etruscan and he wanted to emulate them), and the contrast will not only be between red and black on the one side and Wedgwood's soft duck-egg blue on the other, but also between every form and outline, full-bodied in Greece, attenuated in England [71 a and b]. Flaxman who worked for Wedgwood spoke of the 'barbarous violence of angular action' in genuine Greek vases,[16] and his delicious out-line drawings to Homer compared with the scenes painted on the Greek vases show indeed once again the same contrast.

However, and this needs a good deal of stress, the shallower, more elongated curve does not necessarily mean a lack of ten-sion. A warning against that error was already sounded, when illumination in 1300 was discussed. One need only compare Flaxman [72a] and Fuseli [72b], both inspired by Homer and Dante, to see the difference. Fuseli also stretches his bodies and bounds them by long curves, and he also, in spite of hysterically exaggerated muscular displays, does not really work in the round. But his lines have an excessive tension unique in the England of his time; the ferocity of his stretched-out arms and of his legs set widely apart is unmistakable. But then Fuseli had originally been Füssli. He was Swiss, and Benjamin Haydon shrewdly observed about Fuseli's *Ghost of Hamlet's Father* that it is 'a German ghost', alluding no doubt to the savagery of Fuseli's style.[17]

What English tension in terms of English line looks like, no one can tell better than Blake who, after having contributed the title to this chapter, now appears belatedly on the stage. 'Mental things are alone real, what is called corporeal . . . is . . . an Imposture.'[18] 'Imagination is My World; this world of Dross is beneath my notice.'[19] 'Those who restrain desire, do so because theirs is weak enough to be restrained.'[20]

72. LINEARISM in the late eighteenth century, tender or tense: (a) John Flaxman's and (b) Henry Fuseli's illustrations to Homer.

Such were his convictions, such his theories. No one can overlook that they were formulated as challenges to the England of Hogarth as well as of Reynolds. We cannot here dwell on the ways in which Blake developed them and expressed them, his obscure private mythology, his passionate hatred of oppression by government and by the ironmaster and millowner, and so on. But we have to remember all that, and remember the reality of his visions – 'After dinner I asked Isaiah'[21] – and the uncomfortable closeness of some of his graphic work to the art of the insane: the way he covers all the free spaces on his engraving of the group of Laocoon (which he calls *Jehovah and his sons Satan and Adam*) with oracular sayings in all directions.[22]

All that must be remembered. Then, when one sees at the top of this very engraving the line 'Where any view of Money exists, Art cannot be carried on',[23] the total contrast to all the painters so far included in this book as most English comes out forcefully – and with it the need for considering national character in contraries or polarities. Reynolds's was bound to be a profitable practice, but Gainsborough's also was, and so were those of the other portraitists of their age. And Hogarth saw no reason why he should not admit that he turned to his new field of 'modern moral subjects', because what he had done until then 'was not sufficiently paid to do every thing my family requir'd'.[24] Blake never was able to pay the expenses his household required. He was a humble engraver, ready, as we saw, to accept catalogue work for Wedgwood's. His poetry, his prophecies, his painting remained unprofitable and were acclaimed by few. They, Thomas Butts, and later John Linnell of Wyldes, kept him alive.

As far as this book is concerned, Blake's life is, however, less interesting than his style. No one can fail to recognize a Blake. Everywhere, whether the scene is one of bliss or terror, are his long, attenuated bodies, boneless almost, one feels, so little does he articulate the nude body, so ready is he to bound the joints of an up-stretched arm within gliding curves. Everywhere are his

*ua magna est super cælos misedi
a: uusqz ad nubes ueritas tua*

73. By elongation and swaying curves and double-curves weightlessness is achieved in (a) Queen Mary's Psalter of *c.* 1300 (British Museum) and equally in (b) a Blake water-colour of 1803 (*The Three Maries at the Sepulchre*, Fitzwilliam Museum, Cambridge).

small, strangely impersonal heads, and his flowing beards, his
garments also flowing gently or falling loosely and evenly in
perpendicular curves [73b and 75a]. They are of light, imma-
terial stuff.[25] The curves, however, according to the character of
the scene can be tense or tender, the lines flaming or flowing,
that is inspired by, or sometimes rather in harmony with, Fuseli
or Flaxman, who were both friends of Blake. Fuseli certainly
inspired him. He was sixteen years Blake's elder, and his style,
as developed in Rome in the 1770s was complete when Blake
began as an engraver in Basire's workshop. Another equally
important inspiration in the same years was Gothic sculpture,
and that also is very telling. 'Grecian,' he once wrote, 'is
mathematical form, Gothic is living form.'[26]

Gothic sculpture he knew from Westminster Abbey, where

74. LINE AND NOT BODY
in Anglo-Saxon illumina-
tion. Peterborough Psalter,
early eleventh century. Bod-
leian Library, Oxford.

75. (a) THE TENDER CURVES of William Blake compared with (b) illumination about 1300. (*The Finding of Moses*, Victoria and Albert Museum, London. Crown copyright. The Couce Apocalypse, Bodleian Library, Oxford.)

he had drawn for Basire, but he must also have seen Gothic illuminated manuscripts; for his printed books, written, drawn, and printed by him, are a renewal of the unity of the book page as it had been a matter of course in the Middle Ages. It is eminently characteristic of Blake that on the pages of *The Songs of Innocence*, or *America*, or *Jerusalem* [76], or any of the others of his books, figures, trees, and script are all drawn together and all of a piece. That means that his figures are not primarily representations of bodies, but part of an overall calligraphy. It is equally characteristic that Blake places his figures so often in a row, many long, parallel, vertical curves of drapery folds and gestures – much as the illuminators of 1120 had done in hard, and the illuminators of 1300 in sinuous, uprights. He also, surprisingly often, shows his figures floating in a cloud and becoming part of it, or in a stream and becoming part of it, or rising in a flame and becoming part of it. In other cases, where energy rather than abandon is intended, he forces figures into an imposed abstract geometry. This is the case for instance in *The*

76. THE FLAMING
LINE of William Blake.
The last page from
Jerusalem.

Ancient of Days [77], kneeling in the clouds within a perfect circle, his hair and beard blown perfectly horizontally, his one leg standing perfectly vertically, the other a triangle, his arms stretched down to set 'his compass upon the face of the depth' – and the compass makes a perfect right angle. In a similar sense one finds the rainbow used and the crescent and the gigantic posts and lintel of a druidic monument.

This imposition of an abstract geometry allows us for a moment to introduce the greatest English architect of Blake's day, Sir John Soane, a contemporary of Blake's, only four years his elder. It is apt that he should appear here; for what characterizes his entirely personal, highly idiosyncratic, and often eccentric style – he has been mentioned for a moment before for

77. THE TENSE GEOMETRY imposed by Blake on some of his figures. *The Ancient of Days.* Whitworth Art Gallery, Manchester.

his eccentricity only – is that he also liked the incised line as an ornament instead of anything more bodily and swelling, and that he built in an overwhelmingly English way with surfaces which are like membranes and with shallow curved vaults which seem to hover over the rooms [78]. The Greek Revival in other countries tends to emphasize mass and solidity, only English Soane contrived to disembody it.

And to return to Blake and his imposed geometry, he applied it even to his portraits – if that term can be applied to any of Blake's works. There certainly are visionary portraits by him such as the strange *The Man who built the Pyramids*, and the even stranger *Ghost of a Flea*, and there is also, though of course with the imposed geometry much softened, the straightforward

78. THE LINEARISM AND DISEMBODIMENT of Sir John Soane's interiors. The Monk's Parlour at Sir John Soane's Museum, London. Coupled with the total lack of sense of mass and weight of the structural parts is a delight in intricacy and spatial surprise paralleled only in English architecture of about 1300 and in English landscape design of the eighteenth century.

portrait head of John Varley, the astrologer, for whom he drew *The Man who built the Pyramids*.

It does not need saying that Blake was not a portrait painter, that he could not be one. Portrait in the accepted sense for him stood for all that was evil, debased, mechanical in England. It belonged to what he called 'the sordid drudgery of facsimile reproductions of merely mortal . . . substances', yet was the only art 'applauded, and rewarded by the Rich and Great'.[27] Fuseli was one with him on this count. He has already been quoted as saying, 'There is little hope of poetical painting . . . in England. . . . The People are not prepared for it. Portrait with them is everything.'

And curiously enough Gainsborough also agreed with these remarks, though less emphatically and for very different reasons. He was a successful portrait painter. But, as his yet more success-ful chief competitor Reynolds hankered after the historical and ideal subject, so Gainsborough hankered after landscape. In a famous letter to a friend he wrote:

I am sick of Portraits and wish very much to take my viol-da-gamba and walk off to some sweet village where I can paint landskips and enjoy the fag-end of life in quietness and ease. But these fine ladies and their tea-drinkings, dancings, husband-huntings etc. etc. etc. will fob me out of the last ten years. . . .[28]

So with him it was not poetical painting or imaginative painting versus portrait, but landscape versus portrait – and that also is an eminently English problem in the eighteenth century. It is the one to which we must now turn.

CONSTABLE AND THE PURSUIT OF NATURE

Constable never visited Italy, nor did he visit Paris. Neither did Blake, neither did Gainsborough, neither did Hogarth. There is evidence that Constable never seriously wanted to know Italy. There is a passage in a letter written when he was over fifty about someone's 'mind and talent mouldering away at Rome'.[1] In an address to students of the Royal Academy he warned them 'not to be in too great haste to [seek] instruction in the schools of France, Germany, or Italy'.[2] Yet he was an ardent worshipper of Claude Lorraine's Italian landscapes and once wrote to his friend Archdeacon Fisher that he feared he might be 'doomed never to see the living scenes that inspired the landscapes of . . . Claude'.[3] However, this passage immediately goes on like this: 'But I was born to paint a happier land, my own dear old England; and when I cease to love her, may I, as Wordsworth says, "never more hear her green leaves rustle, and her torrents roar".'

Constable loved his country, and if such love can be taken as an indication of frank, naïve Englishness, then Constable ought to be as promising for an analysis of Englishness as Hogarth, who signed himself 'Britophil', and Blake who called himself 'English Blake'.[4] Blake and Constable are contemporaries, and they are what Blake called 'Contraries'. They have indeed

hardly anything in common. Nor have Constable and Reynolds nor indeed at first sight Constable and Hogarth. Yet between Constable and Hogarth comparisons are not out of the question. 'Nature is simple, plain, and true in all her works.' Constable could have said that, but Hogarth did.[5] 'By a close observation of nature [the artist] discovers qualities . . . which have never been portrayed before.' Hogarth could have said that, but Constable did.[6] And one of Constable's most famous sayings, as a rule misquoted, is: 'There is room enough for a natural *peinture*.'[7] That is just what Hogarth must have felt, when he revolted against 'this grand business'. Constable's revolt was couched in almost the same words. He wrote: 'I have heard so much of the higher walks of art, that I am quite sick.'[8]

Blake, on the other hand, said: 'No Man of Sense can think that an Imitation of the Objects of Nature is the Art of Painting, or that such Imitation . . . is worthy of Notice.'[9] That, curiously enough, although admittedly with a very different meaning, might have come straight out of one of Reynolds's *Discourses*. But Blake also said: 'Natural objects always . . . do weaken, deaden, and obliterate Imagination in me,'[10] and that neither Hogarth nor Constable could have written, nor Reynolds either.

Concerning Englishness, however, it is, as these chapters are trying to prove, patent in all of them. But Reynolds's is the world of social convention and intellectual discipline, Hogarth's is the noise and bustle of London low life and high life, Blake's is a dim druidical Albion. As for Constable his England is the countryside, and more specifically the Suffolk countryside, where he grew up, the son of a miller. There his art, as he said so truly, 'is to be found under every hedge, and in every lane'.[11] So is of course Hogarth's under every pub-sign and in every alleyway of London.

But there the comparison between Constable and Hogarth ends. For Hogarth is a story-teller and Constable is emphatically not, and Hogarth wants, as Garrick put it, to 'charm the mind and through the eye correct the heart',[12] whereas Constable had

no such extraneous programme. He seems thereby to contradict
the Englishness of literary painting. But the contradiction is only
on the surface, and can be solved by a look at the change which
had taken place in the art of the whole of Europe between the
Age of Reason and the Romantic Age. Observation remained,
but it was no longer the observation of man in his actions but the
observation of nature. Nor was it incidentally any longer so much
the observation of man simply in his likeness. That is: although
portrait went on as an English speciality, the calibre of English
artists that concentrated on portrait in the eighteenth century,
Reynolds, Gainsborough, Romney (and in Scotland Raeburn),
now went into landscape. The years between just before 1800
and about 1840 saw a prodigious flowering of landscape painting
in England, unparalleled in any one country on the Continent.

The development starts two generations earlier, in the mid
eighteenth century, when Richard Wilson came back from Italy
and turned from the idyllic landscapes of the south to English
and Welsh landscape. 'He looked', as Constable said,[13] 'at
nature entirely for himself, and remain[ed] free from any tinc-
ture of the style that prevailed among the living artists, both
abroad and at home.' Side by side with him, with an equally
fresh eye, Gainsborough painted his landscapes [79], a pursuit
which, as we know, he preferred to painting portraits. His land-
scapes have indeed the happiest insouciance of handling and the
most 'soothing, tender, and affecting' sentiment. The quoted
words are Constable's again.[14] Far bolder is the handling of
Alexander Cozens's landscapes [80]. For their groundwork they
have ink-blots crossed by an accidental network of lines which
is created by crumpling the paper and smoothing it out again
before the blots are made. The result has a breadth of vision, a
weightlessness, and a sense of atmosphere prophetic of the
nineteenth century, and it may be worth recording that even
Constable made at least one blot drawing.[15]

But there is yet a fundamental difference between Wilson,
Gainsborough, Alexander Cozens, even Alexander's son John

Robert Cozens whom Constable once called 'the greatest genius that ever touched landscape',[16] and Constable. All the masters of the eighteenth century have in their compositions and their stylish handling of the brush still a self-consciousness which reflects the century's sense of superiority over nature. Nature must be composed, that is improved – in this the landscape painters agreed with Reynolds and incidentally with the 'improvers' *par excellence*, the eighteenth-century landscapers led by the Rev. William Gilpin, their theorist (who also made a blot drawing).[17] To him and the English theory of landscape we shall turn in the next chapter.

79. THE BEGINNINGS OF ATMOSPHERIC LANDSCAPE: Thomas Gainsborough's *Herdsman Watering Cattle*. British Museum, London.

80. THE BEGINNINGS OF ATMOSPHERIC LANDSCAPE: Alexander Cozens's *Landscape with Chasm*. Collection Sir Kenneth Clark, Saltwood Castle.

All that still lingered of artificiality was driven out by Thomas Girtin [81], who died young in 1802, and then by Crome and Turner and Constable. It is characteristic that Girtin and Turner started from the architectural portrait, that is accurate representations of buildings understood in their structure and character. They continued in this the Anglo-Venetian tradition of the *veduta*. Canaletto had stayed in England from 1746 with a short break till 1755. Sandby had been working in the same spirit in English water-colours. But no one in the eighteenth century had the closeness and density of rendering of Girtin and Turner. It is equally characteristic that Crome's and Constable's chief sources of inspiration were the Dutch landscape painters of the seventeenth century who combined probity with a feeling for atmosphere stimulated by the climate of their country. The climate of England is similar, the closeness to the sea as noticeable in the air. So Girtin and Turner as well as Crome and Constable turned to the study of atmosphere, allowed it to animate the English everyday country scene, and developed an open and sketchy technique to interpret an ever-changing nature.

81. THE STUDY OF ATMOSPHERE IN EVERYDAY ENGLISH LAND-
SCAPE: Thomas Girtin, *Copenhagen House, Islington, c.* 1800. British
Museum, London.

This pre-eminently painterly technique was, however, not
created at that time nor in England. It is the direct descendant
of the later style of Titian, in his figures as well as his fabulous
landscape backgrounds, the style of Rubens's landscapes and
those, once more, of the Dutch. In England it appeared out of
the blue with Hogarth – but he, as has been shown, did not want
to be a painter primarily, but a teacher of morality, as Reynolds
wanted to be a teacher of social virtues. Hence both could write on
the theory of art as well, whereas for instance Gainsborough could
never have done that. This is one of the reasons why Reynolds
in that embarrassing document, the Thirteenth Discourse,
blamed him, in spite of respect and a sensitive appreciation of his
technique. The wording of his reproof is extremely interesting.
Reynolds said that Gainsborough saw nature 'with the eye of a
painter' and not a poet. It seems absurd to us, after a century of
Impressionism, to blame a painter for seeing with the eye of a
painter, but it shows up the conflict of the late eighteenth century
out of which the great English art of landscape painting arose.

A little more must now be said of the character of Constable's

landscape. The motifs are humble, Dedham Vale, Hampstead Heath, Willy Lott's Cottage, boat-building near Flatford Mill. As C. R. Leslie, his early biographer, writes, he worked, 'within the narrowest limits in which, perhaps, the studies of an artist ever were confined',[18] but his aim could 'be best attained by a constant study of the same objects under every change of the seasons, and of the times of day'.[19] The sky Constable called indeed 'the keynote'[20] of all classes of landscape. Neither Poussin nor Courbet nor Cézanne could have said that. And clouds were Constable's delight and obsession.[21] Alexander Cozens already had intended to publish a system of skies in twenty-five varieties and left indeed a number of memorable cloud studies. Constable, in one of his letters to C. R. Leslie, suddenly breaks off to exclaim: 'I can hardly write for looking at the silvery clouds.'[22] On his cloud studies [82] one finds entries such as this:

September 5, 1822, ten o'clock, morning, looking South-East, brisk wind at West, Very bright and fresh, grey clouds running far over a yellow bed, about half way in the sky.

Of Girtin a similarly close observation of 'the time of day, the cast shadows and particular effect suited to the time' is reported.[23] And Constable in a lecture he gave towards the end of his life to the Literary and Scientific Society of Hampstead analysed a winter landscape by Ruisdael in the following terms:

The picture represents an approaching thaw. The ground is covered with snow, and the trees are still white; but there are two windmills near the centre; the one has the sails furled, and is turned in the position from which the wind blew when the mill left off work, the other has the canvas on the poles, and is turned another way, which indicates a change in the wind; the clouds are opening in that direction, which appears by the glow in the sky to the south (the sun's winter habitation in our hemisphere), and this change will produce a thaw before the morning.[24]

Constable added that these details in Ruisdael's picture show that he 'understood what he was painting', and that

82. ATMOSPHERIC PAINTING IN ITS PUREST FORM: John Constable, cloud study, probably of 1822. National Gallery, London.

he 'has here told a story' – both remarkable statements. He praised the same mastery of atmospheric rendering in Rubens's landscapes: 'dewy light and freshness, the departing shower, with the exhilaration of the returning sun, effects which Rubens, more than any other painter, has perfected on canvas'.[25] In describing his own paintings Constable emphasized exactly the same atmospheric qualities, 'dew and breezes',[26] 'a shower has just passed',[27] 'silvery, windy, and delicious . . . all health, and the absense of everything stagnant' [83].[28] 'Sparkle and repose' are the two extremes he wanted to combine.[29] He knew what he was doing, and there is no false modesty in what he writes about his achievement: Never before had such an interpretation of nature as his been 'perfected on the Canvas of any painter in the world'.[30]

Fuseli, who belonged to the eighteenth century and the world of Blake, said of Constable: 'He makes me call for my greatcoat and umbrella.'[31] But Blake himself, when he saw drawings by Constable, said: 'Why, this is not drawing but inspiration.' Constable answered: 'I meant it for drawing.'[32] Even so,

83 and 84. The contrast between Constable's atmospheric landscape and Turner's late fantasmagorias of atmosphere: *Hadleigh Castle,* *c.* 1829, National Gallery, London; and (below) *Norham Castle,* *c.* 1835–40, Tate Gallery, London.

however, he did call himself a visionary to excuse being irritable with clients and dealers[33] – the very word Blake used with so much more justification. It is not unlikely that to Constable the word had an undertone of vision in the optical sense. In any case the last sentences of the last of a course of lectures he gave at the Royal Institution in Albemarle Street nine months before he died are: 'Painting is a science, and should be pursued as an enquiry into the laws of nature. Why, then, may not landscape painting be considered as a branch of natural philosophy, of which pictures are but the experiments.'[34]

From here the return is easy to that eternal quality of Englishness, the rational approach. In Constable it might not have been expected. The atmospheric approach is just as English, and so is of course Constable's primary choice of landscape as his exclusive subject. The position is this. Constable in landscape, Reynolds, Gainsborough, and all other painters of portraits, and Hogarth, the painter of contemporary comedies of manners are all equally intent on close observation of what is around us.

But while Constable is here at one with Reynolds and Hogarth, he is at one with Blake and also with what is most English in English medieval architecture in that his is not a world of bodies, self-consciously displaying their voluminous presence. This anti-corporeal attitude being part of the English heritage, it was England in the Romantic Age that led Europe away from the landscape arranged of carefully disposed masses and towards the atmospheric landscape. That Claude Lorraine in Rome and also, as has been alluded to before, such Dutchmen as Cuyp had done much the same already in the seventeenth century, need not detain us. The fact remains that Constable's searching naturalism is devoted to air and that Turner's anti-naturalism carried him away into fantasmagorias of nothing but air [84]. 'Golden Visions,' wrote Constable, 'but only visions',[35] and Hazlitt is supposed to have spoken less respectfully of 'tinted steam'.[36] Constable knew the merits and dangers of Turner's art well. He calls one of Turner's pictures 'the most

complete work of genius I ever saw'[37] and praises his light as 'exquisite',[38] but he also believed that Turner, like 'every man who distinguishes himself in a great way, is on a precipice'.[39] Turner, in Constable's eyes, 'does violence to all natural feelings',[40] and once in a letter Constable calls him 'stark mad'.[41]

Turner's position in English art is indeed baffling from whatever point of view one considers it – also from that of his Englishness. In his command of the vast and nebulous he belongs to Milton and also, it might be added, to Blake, though in his command of atmospheric situations his is the world of Constable and indeed of those of the other great English landscape painters of between 1800 and 1840, immensely varied in character and personality as they were. Blake's own few landscapes range from the completely disembodied *God moving on the Face of the Waters* to the small wonderfully compact, yet entirely unreal woodcuts for Thornton's Virgil, which almost at once released Samuel Palmer's youthful genius and gave us the landscapes of his visionary years.[42] Many years later Palmer spoke of the 'Raving mad splendour of orange twilight glow'[43] in these landscapes. While he painted them, he wrote: 'I will, God help me, never be a naturalist by profession.'[44] The surface of a Palmer landscape is, to quote him again, all 'sprinkled and showered with a thousand pretty eyes, and buds . . . and blossoms, gemm'd with dew'.[45] Both Henry Moore and John Piper owe much to Palmer's delight in 'dappled things'.

Cotman, with the heavenly peace of his smooth flatly and coolly coloured landscapes, seems the very reverse of Palmer. Yet what they have in common is the intensity of feeling for nature combined with an unreal coherence of the surface, independent of the corporeal shapes lying as it were behind. A look at any Bonington landscape will show what draws Cotman and Palmer together. Bonington has the bold open brush strokes of Constable, the sense of breeze and never once arrested change. He was a natural painter. Things came easier to him than to

Constable. Both of them stand together as the inspirers of the great French school of the mid and late nineteenth century. Bonington died as early as 1828. Constable died in 1837; with David Cox and plenty of good minor painters in water-colour this broad English achievement carried on beyond 1850. By then the great art of English painting was dead altogether – for

85. (a) A masterpiece of medieval sculpture, but on a small scale. Roof boss of the Angel Choir at Lincoln Cathedral, *c.* 1260. (b) The English concern with small scale which was responsible for the preference of water-colour over oil-painting in much of the best English landscape of the late eighteenth and early nineteenth centuries is also responsible for the much higher quality achieved in Tudor and Stuart miniature portraits than in large-scale oil-paintings. Nicholas Hilliard's *Young Man among Roses*, Victoria and Albert Museum, London. Crown copyright.

reasons which can only be understood on a broader basis of cultural changes, changes to which we must revert later.

That in this flowering of English landscape, water-colour painting plays such a prominent part, a part never equalled in any other country, is also to be explained by characteristic English qualities of the medium. Small scale appeals to the English rather than grand scale – the roof-bosses and capitals in the churches [85a] and not the statues on the façades, and also miniatures painted minutely on parchment or cardboard. English portrait painting of the Elizabethan Age was almost monopolized by foreigners like Eworth and the Gheeraerdtses, except for the miniaturists, and they, especially Nicholas Hilliard [85b] and Isaac Oliver, did more accomplished work than the Netherlanders in oils. But it was not only the small scale of the water-colour that appealed to the English of the eighteenth and nineteenth centuries, it was also the thin semi-transparent character of the medium, so much less full-bodied than oil.

And side by side with the pure landscapes there flourished in the later eighteenth and early nineteenth centuries such English specialities as the sporting picture. It is characteristic enough that it is a speciality, but the way it is handled is equally characteristic. Mr Basil Taylor has recently published a book on animal painting in England.[46] The title of the book is telling; for it deals little with the popular sporting picture of the Alken and Leech kind, which may be skilful reporting or boisterous cartooning but does not reach higher. Where animal painting is at its best, where even the racing picture is at its best, there is no exciting action, but a curious stillness. That is the secret of Stubbs, the greatest animal painter in England [86].[47] Stubbs, besides being a painter, was a scholarly student of anatomy, and he went to Italy in 1754 'to convince himself that nature . . . is always superior to art, whether Greek or Roman'.[48]

Another English speciality is the open-air portrait; other countries – at least before the Impressionists of the 1860s and 1870s – have nothing like it. It goes right back to the *Portrait of*

86. THE SPORTING PICTURE: George Stubbs, *The Prince of Wales's Phaeton and Thomas, the Coachman*, 1793. Windsor Castle.

87. THE OPEN-AIR POR-TRAIT: Thomas Gains-borough, *The Duke and Duchess of Cumberland out for a Walk*, c. 1780–5. Windsor Castle.

an Unknown Nobleman at Hampton Court of the mid sixteenth century, and it culminates with such delightful pieces as Gainsborough's *Morning Walk*, or *The Duke and Duchess of Cumberland out for a Walk* [87], or Zoffany's *The Garricks taking Tea* [88] on the lawn by the River Thames at Twickenham, or in a more romantic mood Joseph Wright of Derby's *Brooke Boothby* lying in a wood and dreaming over a book he has been reading, or – to point to the same delight in fresh air in Scotland – Raeburn's *Sir John and Lady Clark* walking through their possessions and no doubt discussing improvements.

88. THE OPEN-AIR PORTRAIT: Johann Zoffany, *The Garricks with Dr Johnson taking Tea on the Lawn in front of their Villa at Twickenham, c.* 1773. Collection of the Earl of Durham.

For that is really the setting in which the open-air portrait and the sporting picture must be seen – the passion of the eighteenth-century English for the landscape garden and the passion of the present-day English for gardening which is the latter-day poor relation of landscaping. The landscape garden is the most influential of all English innovations in art. Its effects can be studied all over the Continent and from the United States to Russia. It deserves a chapter to itself.

Any account of landscape gardening must start from the English climate, as indeed English landscape painting and the English sporting picture and open-air portrait can also be appreciated only by taking climate into consideration. Climate is – as was stated in the introduction to this book – one of the fundamental premises of character. The English climate has been discussed so often and ridiculed so often that it may be high time to quote a different view. It is that of Charles II, who had been brought up in France and so knew climes nowadays regarded as more attractive. Yet he said that 'he lik'd . . . that Country best, which might be enjoy'd the most Hours of the Day, and the most Days in the Year, which he was sure was to be done in England more than in any country whatsoever'.[1] One is inclined at first to think that this is a king's blatant flattery of his country. But it must not be forgotten that Rochester who was not what one would call a kind man in his judgement of others said once that Charles 'never said a foolish thing' (though he added: 'Nor ever did a wise one'), and that no man in the seventeenth century would have called scorching sunshine something to be enjoyed outdoors. So outdoor life at that time and right to the nineteenth century required moderate weather – too warm not to want to be outdoors, too cool to be idle outdoors. Hence English sports,

hence English gardening, hence the Englishman digging his own bathing-pool, or building his own garden wall. Weather suitable for such pursuits does indeed turn up for some time on nearly every day in England, however much moisture there may be in the atmosphere lying in wait to condense into rain.

That moisture steams out of Turner's canvases as well, makes Constable's so uncannily clear and fresh, and lays a haze over man and building, dissolving their bodily solidity. It thus links up with the incorporeal tradition of English art. And it made the English, to return to the business in hand, the creators of landscape gardening and thereby of the Picturesque. The English Garden [89], the *Jardin Anglais*, the *Englischer Garten*, is asymmetrical, informal, varied, and made of such parts as the serpentine lake, the winding drive and winding path, the trees grouped in clumps, and smooth lawn (mown or cropped by sheep) reaching right up to the french windows of the house.

The English garden is English in a number of profoundly significant ways not yet touched upon. First the simplest way: formally the winding path and the serpentine lake are the equivalent of Hogarth's Line of Beauty, that long, gentle, double curve which dominates one kind of English art from the Decorated style in architecture to William Blake and beyond. On the other hand, where Hogarth himself uses these motifs of the garden to illustrate his point, he says that they 'lead the eye a wanton kind of chase'.[2] That is clearly something different. It introduces such elements as surprise in the composition of the English garden, and surprise was indeed one of the elements consciously aimed at:

> Let not each beauty everywhere be spied
> When half the skill is decently to hide.
> He gains all points who pleasingly confounds,
> Surprises, varies, and conceals the bounds.

These lines are from Alexander Pope,[3] and though Pope was a teacher of reason, and though it was Lord Burlington who established in eighteenth-century England the clarity and the cubic

simplicity of Palladian architecture, Burlington possessed at Chiswick and Pope at Twickenham two of the first Picturesque gardens of England. They were begun about 1718.[4]

Pleasingly to confound is not what English Palladian houses are supposed to do. Yet in the course of the eighteenth century an element of surprise developed in the management of their interiors. It becomes first noticeable in Kent's and then Robert Adam's delight in columnar screens half concealing the apsidal bounds of a room.[5] Externally the same screen or grille effect was obtained in Adam's portico at Osterley Park which instead of standing in front of a solid wall half-reveals the inner court-yard behind. The master of surprise in internal spaces is Sir

89. THE ENGLISH GARDEN: the landscaped grounds of Claremont, Surrey.

John Soane. His own house is full of unexpected and not easily comprehended effects of concealed lighting, concealed structure, and unexpected changes of level [78, p. 155]. No one in Europe at Soane's time is his match in such truly Picturesque effects.

Nor is there a consistent English tradition behind them, although we could refer to the fact that, at the time which in medieval architecture seemed to us the most convincingly comparable to that of Soane (and Blake), that is about 1300, there were also spatial surprises achieved which have no equal on the Continent. The paramount examples have been mentioned before: the chancel of Bristol Cathedral with its confounding diagonal vistas, the Octagon of Ely Cathedral, and the east end of Wells Cathedral.

But surprise or, as Pope said more comprehensively in another place, 'the contrasts, the management of surprises, and the concealment of the bounds'[6] is not all that he demanded of a garden. There is also 'the amiable simplicity of unadorned nature'.[7] To make the garden appear natural is a conception that takes us back to the seventeenth century. On the Continent neither naturalness nor surprise in gardening appeared before the great English invasion of the mid eighteenth century. Sir Henry Wotton, the first coherent writer on architecture in the English language, wrote in 1624: 'As Fabriques should be regular, so Gardens should be irregular.'[8] Two generations later Sir William Temple, in his *Gardens of Epicure* of 1685, wrote more explicitly, after some pages on the formal gardens of his time: 'There may be other forms wholly irregular, that may, for ought I know, have more beauty. . . . They must owe it . . . to some great race of fancy or judgement in the contrivance.' Such, he says, are the gardens of the Chinese. But to attempt them in England would be an adventure 'of too hard achievement for any common hands'.[9]

If the adventure was embarked on, that was due to yet another train of thought. Lord Shaftesbury, the philosopher of the early years of the eighteenth century, praised wild nature, 'where neither Art, nor the Conceit or Caprice of Man, has

spoil'd [her] genuine order by breaking upon (her) primitive state'. To him 'the verdure of the Field' and 'even the rude Rocks, the mossy Caverns. . . , and broken Falls of Waters'[10] represent that natural, unartificial world which roused his enthusiasm.

Addison in *The Spectator* wrote the same more quietly: 'For my own part, I would rather look upon a tree in all its luxuriance and diffusion of boughs and branches than when it is . . . trimmed into a mathematical figure.'[11] That refers to the Dutch and French gardens with their formal parterres and their cut hedges. Pope meant the same when he said: 'A tree is a nobler object than a prince in his coronation robes.'[12] It seems a curious comparison at first, but it refers back, consciously or unconsciously, to Shaftesbury whose enthusiasm was roused by rocks, caverns, and waterfalls because they are 'Nature more truly than the formal Mockery of princely Gardens'.[13]

Now with the 'prince in his coronation robes' and 'the formal Mockery of princely Gardens' politics come into the argument: England is Liberty, France is suppressed by her rulers. Of England, Thomson sang: 'Thee haughty tyrants ne'er shall tame,'[14] and of England and France:

> Shall Britons, by their own joint wisdom ruled . . .
> To Gallia yield? yield to a land that bends
> Depressed and broke, beneath the will of one?[15]

Similar thoughts had come to Addison in Italy in 1701 and made him exclaim:

> Oh *Liberty*, thou *Goddess* Heav'nly bright,
> Profuse of Bliss, and poignant with Delight, . . .
> Thee *Goddess*, thee *Britannia's* Isle adores.[16]

And a similar thought had been formulated briefly and more prosaically already by Paul Hentzner before the year 1600. His remark about the English 'impatience of anything like slavery' was quoted in the first chapter of this book. Many quotations from the sixteenth century to Emerson in the nineteenth, who

said: 'Only the English can be trusted with freedom',[17] and so on into the twentieth could be added. The point needs no more elaboration.

The relation of Picturesque gardening to liberty is not one established artificially by twentieth-century critics. It was familiar to the age itself. Thomson in the poem just quoted from, explicitly contrasts the sylvan scenes of Picturesque gardens 'Such as a Pope in miniature has shown' with the enterprises of 'pompous tyrants',[18] and George Mason in his *Essay on Design in Gardening* of 1768 attributes the creation of landscape gardening in England to the English 'Independency . . . in matters of taste and in religion and government'.[19]

As physical proof of this relation one may perhaps quote the various garden furnishings and follies erected in the grounds of English country-houses to commemorate the American Independence. There is for instance a triumphal arch between the Aberford and Parlington parks in the West Riding of Yorkshire on which one can read: 'Liberty in North America triumphant: 1785', and there are the farms of about 1783 at Greystoke Castle, quoted in a previous chapter and called Jefferson, Fort Putnam, and Bunker's Hill. Such demonstrations of sympathy with the King's enemies would not have gone unpunished in any other country and would still be impossible in most countries of the West today.

But there is yet another aspect of the Picturesque garden in England, and its interpretation by Pope and his generation is, in my opinion, in bad need of some elaboration. It is the aspect referred to by Pope in the lines following immediately after the passage quoted above:

> Consult the genius of the place in all
> That tells the waters or to rise or fall
> Or helps th'ambitious hill the heavens to scale
> Or scoops in circling theatres the vale . . .
> Calls in the country, catches opening glades,
> Joins willing woods, and varies shades from shades.

These lines are a programme of improvements typical of what eighteenth-century landowners did to their grounds. They hardly ever extended the principles of their improvements beyond them. There is in addition the occasional eighteenth-century model village, an old village rebuilt because it had been in the way of some Picturesque vista, and there are occasional remarks in the books on village design. On the town there is to all intents and purposes nothing.

The Picturesque entered the town not in urban terms. About 1800 the first squares of London were landscaped – exclaves of the country in the town.[20] They were welcomed as wholesome and attractive, and they took up in fact, though not consciously, an old and eminently English tradition of the cathedral towns. The English cathedral stands in a close, that is, a precinct, originally as a churchyard turfed and tree-planted, and later landscaped [90 a and b].[21] No greater contrast can be imagined than that say between the surroundings of Strasbourg and Salisbury Cathedrals. The landscaped square became the hall-mark of early-nineteenth-century London, and when in 1825 George IV decided to make Buckingham House his London palace, he (and his architect John Nash) did not build a metropolitan palace like the Louvre [91a] or the palaces of Berlin, Rome (the Quirinal), Stockholm (in spite of the water in front), Madrid, but a country-house with a spreading façade [91b]. The façade known to Londoners is of course an early-twentieth-century addition by Sir Aston Webb and with the *rond-point* in front of it more Parisian than Londonian in spirit. The real front of the Palace faces west, that is faces a spacious lawn, winding paths, and a serpentine lake with an island.

This *rus in urbe* is indeed eminently English, but, when it comes to the problems of today, it has little to contribute. Our problems are those of improvements in towns, including the metropolis, and the laying out or, as it is now called, the planning of new towns or new parts of towns. But even with regard to these urgent problems, so much more serious and portentous

90. Even the English cathedral in its precinct has often acquired a landscape setting. (a) John Constable's *Salisbury Cathedral*, 1823, Victoria and Albert Museum; and (b) a photograph of Salisbury Cathedral.

than those of the country-house and its grounds, the English Picturesque theory – if not its practice – has an extremely important message. We are in need of a policy of healthy, attractive, acceptable urban planning. There is an English national planning theory in existence which need only be recognized and developed. It is hidden in the writings of the improvers from Pope to Uvedale Price and Payne Knight. The first line quoted from Pope on page 178 ran: 'Consult the genius of the place place in all.' The genius of the place, the *genius loci*, is a mythological person taken over from antiquity[22] and given a new meaning. The *genius loci*, if we put it in modern planning terms, is the character of the site, and the character of the site is, in a town, not only the geographical but also the historical, social, and especially the aesthetic character. If one wants to plan for the City of London, one must be sensitive to the visual character of the City. The same exactly would apply to Cambridge, or to a small town with much character such as Blandford, or with little character such as Slough.

Now this kind of consideration is tantamount to treating each place 'on its own merit', and it is therefore an eminently English treatment, even if its Englishness has been forgotten in the nineteenth century and still needs rediscovering now. It is the same attitude applied to visual planning as it is applied, or so one hopes, to their day-to-day work by the Home Office and the Ministry of Pensions. 'Each case on its own merit' is the humane principle to act on, and as early as the mid eighteenth century that cosmopolitan observer Count Algarotti had written that 'everything in England is in proportion with the human beings'.[23] 'Every case on its own merit' may indeed be called the principle of tolerance in action, and there is no more desirable element of Englishness than tolerance. The principle was established early – when Queen Elizabeth I declared after the Northern Rebellion of 1560 that all those who obeyed the law should 'certainly and quietly have and enjoy the fruits of our former accustomed favour, lenity and grace . . . without any

91. ROYAL PALACES: (a) the Louvre, wholly urban and with formal parterres; and (b) Buckingham Palace, a country-house in its grounds transported into the metropolis.

molestation . . . by any person by way of examination or inquisition of their several opinions in their consciences, for matters of faith'.[24] There was admittedly some ambiguity in the wording, and Edward Aglionby, M.P., went further, in a speech in 1571. He said that 'the conscience of man is eternal, indivisible, and not in the power of the greatest monarchy in the world, in any limits to be straitened'.[25] This principle was finally laid down for good by the unbloody revolution of 1688. Locke's first *Letter on Tolerance* came out in 1689. Twelve years later Queen Anne gave one of the principal beams for the building of the still surviving synagogue in Bevis Marks, and the architect, a Quaker, gave his fees to the congregation. That is English, and that is why the first of Voltaire's *Letters on the English* is about the Quakers. In a later letter he says a little less kindly: 'All denominations meet on the Exchange, and the only ones called infidels are those who go bankrupt.'[26]

In planning and architecture today 'each case on its own merit' is called functionalism, and if present-day urban situations were treated functionally, it is obvious that the result would not look like 'the mockery of princely' towns such as Versailles, with symmetry enforced on streets and buildings. The informal – this is a better term than the irregular; for the *regulae*, the rules, were not absent in English landscaping, only they were of a subtle kind – the informal then is at the same time the practical and the English. Voltaire has something to say on English irregularity too, this time apropos Shakespeare:

It seems that up to now the English have only produced irregular beauties. . . . Their poetical genius resembles a closely grown tree planted by nature, throwing out a thousand branches here and there and growing lustily and without rules. It dies if you try to force its nature and trim it like the gardens of Marly.[27]

'Nature,' said Voltaire's Scottish contemporary, the sceptical philosopher David Hume, 'Nature is always too strong for principle.'

An unexpected witness to strengthen the present case is Sir Joshua Reynolds. So far he has appeared in this book only as the rationalist and the purveyor of academic doctrine and reticent portraits. Now this is what, in his Thirteenth Discourse, he says about architecture:

It may not be amiss for the Architect to take advantage some times of . . . accidents, to follow where they lead, and to improve them, rather than always to trust to a regular plan. . . . The forms and turnings of the streets of London and other old towns are produced by accident, without any original plan or design, but they are not always the less pleasant to the walker or spectator on that account. On the contrary, if the city had been built on the regular plan of Sir Christopher Wren, the effect might have been, as we know it in some new parts of the town, rather unpleasing; the uniformity might have produced weariness.

Wren's plan of 1666 is familiar; that there was also another aspect to Wren's ideas on visual planning, Reynolds did not observe. We shall come to it presently. The new parts of London of which Reynolds speaks in 1786 must be the West End from Hanover Square to Portman Square. We may not find them wearisome, as we certainly do not the urban terraces of the same time at Bath or Bloomsbury. On the other hand, what other term than wearisome uniformity would the visually sensitive choose for the High Victorian terraces of South Kensington and of nearly all the poorer inner suburbs of London. Yet → and this shows how careful one has to be in these generalizations – both are the outcome of Liberty. The planning of Bath with circus and crescents and the planning of Bloomsbury with its squares is liberty in the sense of an informal composition taking into consideration sites, conditions of property, balance of building to open space, and so on. South Kensington and the poorer suburbs are liberty in the sense of *laissez faire*, that is of letting the philistine, or the Francophile, or indeed the callous speculator have his way and his money's

worth. No interference with good land-use or bad land-use – at least prior to the most recent legislation.

England suffered from the blight of bad land-use earlier than other European countries, because she had undergone the Industrial Revolution earlier than others, and because her faith in tolerance on the one hand, in private enterprise on the other, had prevented her from checking the fatal effects on the appearance of towns of the rapid growth of industry and urban population. When the reaction came about 1870–1914 (and it came earlier than on the Continent too), it took characteristically enough the form of a return to the Picturesque, and quite understandably it looked to the Picturesque practice as much as, or more than, to the Picturesque principles. So the result – a result to be proud of – was the garden suburb and then the garden city. They succeeded in the blending of small-size housing with nature and the application of the principle of variety to the layout of streets, the provision of footpaths and so on. But they failed in not being truly urban.

Yet Wren's City of London and the Bath of the John Woods had shown how the Picturesque principles of variety and surprise, those visual blessings, could be used in urban terms. Wren's plan of 1666 was formal and Parisian, but when it came to building, and he was commissioned to design over fifty churches for the City of London, he gave their styles the utmost variety his fertile brain and his experimental mind could produce, styles of all kinds, from the grandly classical to the homely Dutch and the imitation Gothic.[28]

The message of the Woods, father and son, is even more important for today. They have proved that with terraces of tall as well as small houses, with squares and crescents and circuses, varied planning in urban terms can be achieved. John Nash in his ingenious and again informal procession (if an informal procession can be conceived) of Regent Street and Regent's Park succeeded even better. Here again was urban scale, variety, and surprise in the bends and turns and well-placed accents

of the street, a combination of grand terraces and lush park, an area of picturesque cottages behind called Park Village, and so on.[29]

So there is plenty of precedent to make use of in our situation today – not by copying but by applying the same principles, the same great English principles. The situation in planning in all countries today calls for two things in particular, both totally neglected by the nineteenth century: the replanning of city centres to make them efficient as well as agreeable places to work in, and the planning of new balanced towns, satellite towns, New Towns, which are towns and not garden suburbs with odd

92. PICTURESQUE PRINCIPLES APPLIED TO URBAN CONDITIONS: Sir William Holford's 1956 plans for the precincts of St Paul's.

93. PICTURESQUE PRINCIPLES APPLIED TO URBAN CONDITIONS: the schemes for the Barbican area in the City of London in their final form, prepared (a) by the Corporation of London in collaboration with Sir William Holford; and (b) by Dr J. Leslie Martin and the Planning Division of the L.C.C. Architects' Department.

94. PICTURESQUE PRINCIPLES APPLIED TO URBAN CONDITIONS: the north-west corner of the Market Square, Harlow New Town, by Mr F. Gibberd.

shopping centres as urban exclaves and a trading estate along the railway. Planning is of course largely a matter of economics, sociology, traffic engineering, and so on, but it is also a visual matter, and if in the end the city centre or new town is not visually satisfactory – not only in its buildings but as an urban whole – it is a failure.[30]

These are urgent problems for all countries, but what has been said about English character shows that no country is aesthetically better provided to solve them and thereby leave its imprint on other countries than England. If English planners forget about the straight axes and the artificially symmetrical façades of the academy, and design functionally and Englishly, they will succeed. There are in fact promising omens in many places already: the consistent policy of the *Architectural Review* over the last twenty years, resulting in sketch-plans for the City, the area round the Houses of Parliament, and several small towns;[31] the Holford and Holden plan of 1945 for the City of London; Sir Hugh Casson's and Mr Misha Black's layout of the 1951 Exhibition on the South Bank of the Thames; Sir William

95. PICTURESQUE PRINCIPLES APPLIED TO URBAN CONDITIONS:
shoppers relax in Town Square, Stevenage New Town, where the trees
have been preserved.

96. PICTURESQUE PRINCIPLES APPLIED TO URBAN CONDITIONS:
(a, b, and c) the Roehampton Estate of the L.C.C., designed by Dr J.
Leslie Martin and the L.C.C. Architects' Department.

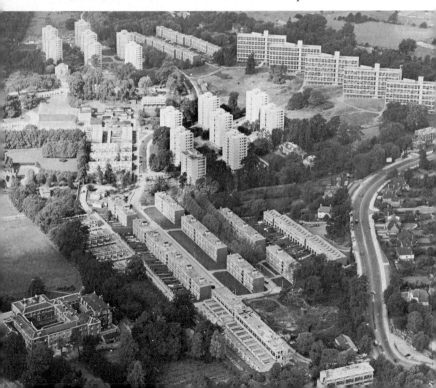

Holford's brilliant plans of 1956 for the precincts of St Paul's [92] on which a start is being made while this book is going to press; the London Wall or South Barbican scheme of the City of London [93 a and b], announced in 1955, since revised and developed, and now happily proceeding; the new Notting Hill Gate by the L.C.C. and Cotton, Ballard, and Blow; the new Elephant and Castle by the L.C.C., E. Goldfinger, and others, all in course of execution; certain parts of Harlow New Town [94] by Mr F. Gibberd; the Market Place of Stevenage New Town [95] by Mr L. G. Vincent; and the superb L.C.C. housing estate for 10,000 at Roehampton [96 a, b, and c], built in 1952–61 to the designs of Sir Leslie Martin and his team of young architects.[32]

These are the things eagerly studied by architects from abroad, but they are also things that still need support, support against ignorance and shortsightedness, and against the stupid prejudice that such newfangled ideas as would give England modern and worthy town and city centres must be outlandish. It has, I hope, been demonstrated how thoroughly inlandish they are.

CONCLUSION

If in planning today England has something of great value to offer to other nations, can the same be said of painting, of sculpture, and of architecture proper?

Concerning painting my answer would on the whole be 'No'. The romantic topography of Christopher Wood and then Mr John Piper, Eric Ravilious, and some others may delight us and be specifically English, but I doubt whether in a future display of twentieth-century painting the English will be among the principal contributors. The reason is not far to seek. At various times in the pages of this book the interaction of the spirit of an age with national propensities has been observed. The two can reinforce one another, as was the case between Hogarth and the Age of Reason, Hogarth and Rococo composition, and between the architectural style of 1300 and the growth of mysticism. In the case of Blake parallels could similarly be drawn to David and Carstens on the one hand, to Runge on the other. In the same sense most English painting today corresponds to painting on the Continent, but whereas Blake is a wholly original interpreter of a European trend of his day, most English painting today, seen from the historian's distance, is a reflection of continental movements. If England seems so far incapable of leadership in twentieth-century painting, the extreme contrast between the

spirit of the age and English qualities is responsible. Art in her leaders is violent today; it breaks up more than it yet reassembles. England dislikes violence and believes in evolution. So here, spirit of the age and spirit of England seem incompatible.

Yet although exactly the same ought to be true of sculpture, it is not. Reference to Mr Henry Moore and other, younger sculptors has been made more than once. The fact remains that, in Mr. Moore certainly, in others probably, England has at present a position in European sculpture such as she has never before held. I have no comment to make beyond that which I have made already. National character is not a procrustean bed. There is nothing stagnant in national qualities, they are in a perpetual flux. New possibilities may at any moment be thrown up and force us to revise our categories.

In architecture the situation is more complex. Looking over the centuries it can be said that England's contribution to Western art has been stronger in the practical art of building than in the more esoteric arts of painting and sculpture. Is there again more promise today in architecture than in the so-called Fine Arts? I would reply in the affirmative, but not unconditionally. England seems predestined to play a leading part in modern architecture. The style clearly harmonizes to perfection with the English tradition of Hardwick Hall and with the whole of the Perpendicular style. It has enough in common also with the cubic simplicity and the ornamental restraint of the Neo-Palladian style. Moreover, it is based, as has been proved, I think, beyond doubt, on the work of William Morris, Philip Webb, Charles Voysey, and other late-nineteenth-century archi tect-designers. Yet the act of creating the new style itself did not take place in England, and its acceptance in England, once it had been created in America, France, and Germany between 1900 and 1910, was singularly slow. The reason for this has also been given before. England dislikes and distrusts revolutions. That is a forte in political development, but a weakness in art.

Moreover, there is another expression of English political

strength which is detrimental to art: the democratic rule by committee and majority. Building today more than ever before is decided by committees. Committees can never be hoped to be the best of judges in matters aesthetic. To demand or merely to license a bold building requires a bold man.

However, rule by committee applies in the twentieth century to countries other than England as well, and yet the progress of the new style seems to have been less hindered by it. The answer may be that other countries trust the one man in the committee or before the committee more than the English, because their democratic traditions are less inveterate – or because they want to believe in the new. In England success of a new venture depends on the lucky accident of a man who believes in it, is insistent, and can at the same time handle committees. Such was Frank Pick at the London Passenger Transport Board, such was Sir Leslie Martin as Architect to the London County Council, such is Mr Frederick Gibberd at Harlow New Town.

Conservatism has been demonstrated as a power of long standing in English art. Ought one then not to accept the wretched Tudor of suburban houses, the genteel Georgian of wealthier suburban houses, and the pompous and petrified Classical Revival of civic centres, city offices, and buildings done for the central government right up to the present day as yet another sign of a permanent English quality? There are two answers to this insinuation. One is that England has not always been conservative. To this fact attention was drawn at the beginning of this book. Right up to a hundred years ago, England was the unchallenged pioneer of innovation, in technology, industry, and commerce. If that has changed – and it undeniably has – causes will have to be found, and they will indeed a little later be discussed. All that matters here is that conservatism, though a recurrent quality in the English character, is not a permanent one.

Also conservatism can be a positive as well as a negative quality. It is negative where it expresses inertia – Sorbière as

early as 1663 said that the English may easily be induced to any-
thing, as long as you fill their bellies, let them have freedom of
speech, and don't bear too hard on their lazy temper.[1] But where
is the border-line between laziness and the desire for a life which
leaves moments or latter years of leisure? Sorbière himself
quotes the English as believing 'that true living consists in
knowing how to live at ease'.[2] Louis de Muralt praised the
English merchants early in the eighteenth century, because 'after
having amassed riches some of them give up trade and become
country gentlemen, that is they know how to stop and enjoy the
fruits of their labour'.[3] And where is the border-line between
circumspection and timidity? The lack of sufficiently bold plan-
ning, the opposition for petty reasons to all major schemes both
in cities and in the country are unquestionably negative. The
staging of the South Bank Exhibition in 1951 twenty-one years
after Asplund's exhibition in Stockholm, the school-drive
thirty years after that in Germany, the conversion to the
point-block fifteen years after Sweden – these delays may on
the other hand have their compensation. Initial mistakes are
avoided, and a certain more human, more leisurely mellowness
can be introduced.

What these thoughts on English conservatism and modern
architecture illustrate is the important fact that national charac-
ter, as it is no procrustean bed, so it is no divining-rod either. We
have no infallible clue to when certain traditional qualities will
reappear and to whether they will appear as beneficial or detri-
mental. The geography of art is no more a science than the
history of art. The qualities which the historian detects, and
dockets, are not only impermanent, they are also ambivalent.
The narrative strain is another example of ambivalence. It can
represent concern with human life and the search for truth, or
on the other hand the preference for the extra-aesthetic aspects
of a story over the aesthetic aspects of a painting.

As regards the permanence of certain national traits the most
likely way to find them is by starting from two things more than

once referred to in the previous chapters: race and climate. Climate is easier to handle, race is a dangerous tool. The ambivalence of any conclusion drawn from race is only too familiar. What can be said of the racial components of the English and their influence on art, has been said in Professor Frey's book. If anything, he tends to overestimate it. What it comes down to is that the Celts had a special delight in the spiral curve and the tight intertwining of such curves and that wherever later interlacing, whirls, and intricacy occur they may be traced back to the Celtic component. A fantastic, spiritual, and spirited element may also be called Celtic. The Angles and Saxons and the Normans on the other hand were active, energetic, practical, and devoted to personal freedom, and those qualities also appear often enough later. But their racial origins help little. It is rare that in an individual artist his racial status is of use in explaining his art. In the case of Hogarth for instance Professor Frey says and quotes from a German anthropologist that his name is Saxon (hog-herd), but the place of his origin in Westmorland is 'an area of the Celtic retreat', and his anthropological type and that of his sister are 'in the direction of an anglo-mediterranean type on a Celtic-West English-Welsh sub-stratum'. What is one to make of that?

To this day there are two distinct racial types recognizable in England, one tall with long head and long features, little facial display and little gesticulation, the other round-faced, more agile, and more active. The proverbial Englishman of ruddy complexion and indomitable health, busy in house and garden and garage with his own hands in his spare time and devoted to outdoor sports, is of the second type. In popular mythology this type is John Bull. In art Hogarth seems to represent it, whatever anthropologists may say. But it is a type less often expressed in art than the other; for it often turns against art. That is why in this book it plays far too modest a part. As was emphasized in the Introduction, a book dealing with art can only demonstrate those national qualities which express themselves in art. It is

doomed therefore to be lop-sided in the end, if it is used as a guide to national character, and not to national art.

We have moved in these considerations from race to nation. For nation, as a self-conscious cultural entity, is always stronger than race. In the United States it is said that it takes two generations to americanize any family from whatever European country. It took American architecture two generations after the achievement of independence to become American.[4] If Holbein's and Van Dyck's English portraits look unmistakably English, that may not prove a change in the style of the two painters, but rather the actually English features and deportment of their sitters. But Rossetti is entirely an English painter, although he was seventy-five per cent Italian, and Whistler is just as English, although he was a hundred per cent American.[5] One may call the sensuality of Rossetti un-English, but one need only compare his women to those of the more sensuous contemporary French, of Courbet or Renoir, to recognize how English his attitude to female beauty and its display really is. And as for Whistler, his over-emphasis on disintegration by atmosphere, so much more extreme than in Monet or any other French Impressionist, and also his long attenuated figures and his preference for the whole-length portrait are all familiar English traits.

But here also no rule can be made. Sickert, it seems to me, remained incorrigibly Bavarian to the end, and yet had much to contribute. In acclimatizing Impressionism in England his robustness was an antidote to Whistler's disembodiment and aestheticism. And England has indeed profited just as much from the un-Englishness of the immigrants as they have profited from the Englishing they underwent. No one in English history is a more telling and encouraging case of this than the Prince Consort.

After race and nation, climate. Here at least one is on safe ground, and that is why climate has appeared time and again in this book. There is nothing new to add. It is a moderate climate, and it is a misty climate, and both these qualities are indeed

immediately reflected – directly or indirectly – in nearly all the characteristics of English art we have found. They are of two classes. On the one hand there are moderation, reasonableness, rationalism, observation, and conservatism; on the other there are imagination, fantasy, irrationalism. Disembodiment, the most significant single formal quality in English art can attach itself to both classes, but is more exclusively related to the second. The first class branches out into such categories as understatement, self-discipline, a practical approach to each individual case. They too may turn anti-aesthetic and prevent self-realization by means of art. Self-discipline may prevent that single-minded enthusiasm or fanaticism indispensable for the highest achievements in art. The practical approach may neglect art altogether. It is indeed the danger in English art through the centuries that compulsion or inevitability of form or style is impeded by reflection and that for practical reasons certain subject-matter in painting is all but excluded. Here is, to repeat it, the reason why there is no Sistine Chapel and no Isenheim Altar in England. But this limitation restricts the so-called Fine Arts more than architecture and design, and if architecture is so clearly responsible for more of the best art of the past in England than painting and sculpture, that is largely due to the fact that architecture is rarely in danger of losing its ties with practical needs.

Examples of the rational side in England have been given from all periods. The irrational is rarer. It rises to a first climax in the seventh and eighth centuries, to a second in the Decorated style of 1300, it contributes much to the Picturesque and something to Hogarth as well as Gainsborough. It reaches a new climax in Blake and the late style of Turner, and ebbs off with John Martin and Danby and the Pre-Raphaelites, to rise once more in the aesthetic movement of the eighties.

But the case of the Pre-Raphaelites shows at once that the two classes are not separable. The Pre-Raphaelites belong to both, their hankering after truth to nature and after the edifying story links them, as has been shown, to the rational, narrative side.

Similarly the Picturesque belongs as much to the side of fantasy as to the side of intelligently understood function.

If the irrational is quantitatively weaker in the visual arts of England than the rational, that is not so, if in English art one includes poetry and oratory, of Milton and Wesley, and much else. And even in matters connected with the visual arts it is perhaps not too much to say that sudden genius, though perhaps odd genius, is more likely to appear in England in the realm of fantasy and the irrational (or unreasonable) than on the opposite side.

So far the two categories of English qualities have been regarded as permanent, though appearing in alternation. But it has been stressed several times that national qualities are far from permanent. There occur every now and then cultural changes, changes of heart and mind, which go so deep that they may bury certain qualities for ever or for a long time and beget new ones. In art such a change is supposed to have taken place at the time of the Reformation, with the result that fine art went under for two hundred years. But, though both lack of demand for certain types of painting and sculpture and Protestantism as such certainly had their effects, the change actually began long before the Reformation. John Siferwas and Herman Scheerre, the leading illuminators about 1400, were German or from the Netherlands, and the best of the masters of the Carmelite Missal has been shown to have come from Holland.[6] So the Perpendicular style as such was perhaps a sign of a weakening of the truly plastic and painterly qualities in indigenous English art, a sign indeed of that movement which predisposed England for the Reformation. And whereas in France the age of the Reformation brought an understanding of the Italian Renaissance and an openness to the adaptation of Renaissance discoveries to French requirements, England remained essentially unconvinced by the Renaissance right through the sixteenth century, because the greatest of the Italian discoveries had been the body and the possibility of swelling anthropomorphic forms in architecture.

Of that the Elizabethans had little notion. The great strength of their architecture is in the line of Perpendicular descent.

The Perpendicular was the first great break in the development of English art. Sculpture never fully recovered. Painting took over three hundred years. Decoration of a freshness and richness such as the thirteenth and early fourteenth centuries had known returned only with Grinling Gibbons and the craftsmen of Kent's time. Architecture was less affected, and no one would deny the qualities of imagination and fantasy, of richness and joy in King's College Chapel at Cambridge.

The next break was Puritanism and the Commonwealth. But curiously enough it is little reflected in art and architecture. Admittedly it took the innovations of Inigo Jones nearly fifty years to become acclimatized. But there is no evidence that, without the Civil War, it would have taken less. Pratt and May, and John Webb follow Inigo Jones in an unbroken succession. Nor is there a hiatus between them and Wren, between Wren and Hawksmoor or Vanbrugh, between Vanbrugh and Kent.

Indeed the next major break in English cultural and aesthetic development happened only in the years between 1840 and 1860. It is less universally recognized, because unconnected with any revolution. Yet it is the break which made the England of today out of an England in many ways staggeringly alien to ours. It cannot be the task of a book such as this to describe the changes in all fields or even sufficiently comprehensively in some. An Impressionist technique may here be permitted.

The most interesting witness of English life about 1850 is Ralph Waldo Emerson.[7] He was an immoderate admirer of things English. 'England,' he says, 'is the best of actual nations.'[8] She has 'in the last century . . . stamped the knowledge, activity, and power of mankind with its impress'. Every nation is 'aiming to be English'.[9] 'The stability of England is the security of the world.'[10] Emerson's shrewdness is beyond doubt. Time and again, it will be seen, he picks out traits which seem eternally typical of the English, and which have therefore found their

various places in this book. There is no better summing-up of its arguments than in his words. 'The practical commonsense of modern society . . . is the natural genius of the British mind.'[11] 'The bias of the nation is a passion for utility.'[12] 'The English mind turns every abstraction it can receive into a portable utensil.'[13] 'The Englishman has acute perceptions', but 'shrinks from generalization'.[14] He has a firm 'belief in the existence of two sides'[15] and 'a supreme eye to facts'. But the logic of Englishmen is a logic that 'brings salt to soup . . . oar to boat. Their mind is not dazzled by its own means, but locked and bolted to results.'[16] 'They have difficulty in bringing their reason to act, and on all occasions use their memory first.'[17] There is, in 'this all-preserving island'[18] 'a dreg of inertia which resists reform in every shape'.[19] 'Every one of the islanders is an island himself, safe, tranquil, incommunicable.' He is 'never betrayed into any curiosity or unbecoming emotion'.[20] 'Inspiration' to him 'is only some blowpipe or a fine mechanical aid'.[21] 'The religion of England is part of good-breeding.'[22] 'The Bishop is elected by the Dean and Prebends of the cathedral. The Queen sends these gentlemen a *congé d'élire* – but also sends them the name of the person whom they are to elect. They go into the cathedral, chant and pray, and beseech the Holy Ghost to assist them in their choice; and, after these invocations, invariably find that the dictates of the Holy Ghost agree with the recommendations of the Queen.'[23] Finally the other side, the side which, as we have seen, is least reflected in art : 'They box, run, shoot, ride, row, and sail from pole to pole.'[24] They 'pound each other to a poultice' then 'shake hands and be friends for the remainder of their lives'.[25] 'They have sound bodies and supreme endurance.'[26]

So far so good. But Emerson is surprisingly unconvincing in a number of other points, and it is them that we have to study to recognize the break in the national character which occurred about the middle of the nineteenth century.

'The nation is accustomed to the instantaneous creation of wealth', and 'there is no country in which so absolute a homage

is paid to wealth'.[27] That sounds American to us rather than English, and it is indeed odd to read an American a hundred years ago attributing to England so much that is now American. The English 'gather and protect works of art, dragged ... from revolutionary countries, and brought hither out of all the world'.[28] The English university, and that was Oxford, Cambridge, and London only, compares with the American like 'the steam hammer with the music-box'.[29] 'An Englishman labours three times as many hours in the course of the year, as any other European.' 'Everything in England is at a quick pace.'[30]

Surely that has changed. And side by side with this change, if Emerson is right, there must have taken place another, embracing the whole of the national character. 'The Englishman', writes Emerson, 'speaks with all his body.' He is 'loud and pungent in his expressions of impatience'. 'His vivacity betrays itself at all points.'[31] He 'will not have to do with a man with a mask'.[32] He has 'a ringing cheerful voice',[33] and 'the habit of brag runs through all classes'.[34] Finally: 'The English uncultured are a brutal nation.'[35]

Noisy cheer and brutality are not qualities that present themselves as English to the visitor today. Yet Mr Kitson Clark has recently shown how histrionic and hysterical public speaking still was in England about 1830–50.[36] Dr Radzinovicz has shown how cruel and barbaric the law was, how widely delight in watching executions had survived.[37] Laurence and Barbara Hammond have shown the miseries of children's lives in factories and the cruelty of the existence of climbing boys (still in the 1860s),[38] the flogging headmasters of the same decades are well enough known (but soldiers with bayonets had to be called in at Winchester in 1818 to deal with rioting boys), and equally well known is the callous disregard for dignity and cleanliness in some of the cathedrals. At St Albans a public lane ran across the chancel, and the Lady Chapel was used as a school. Of St Paul's, Sydney Smith wrote that its 'most conspicuous features ... were its vast emptiness and its encompassing

dirt'.[39] Another architectural illustration of the mood of before 1840 is the corrupt, if aesthetically successful way in which John Nash, the Surveyor-General, leased land himself, at his own (high) valuation to carry through Regent Street, especially the Quadrant, and also the collateral end of the Regent's Canal north of Regent's Park. He built the houses in the Quadrant himself or lent the money for building them to nominal owners who were at the same time the tradesmen: bricklayer, plumber, glazier, and so on. They thus gave their work free for each other's houses and for Nash. Sir John Summerson calls it a transaction of 'almost incredible intricacy', and the Chief Architect to the Ministry of Works today would find it inadvisable to embark on it.[40]

Of the mid-nineteenth-century change itself and England after the change scarcely anything need here be said. Both are admirably treated in Mr G. M. Young's *Victorian England*.[41] The reform acted from the apex of society downwards: a royal couple, genuinely fond of one another and leading an impeccably respectable married life, a prince consort intelligent, highly educated, industrious, and conscientious, a new ideal of decency, fair play, high-mindedness, and gentlemanliness grafted on to the old, often all but moribund, public schools and established in the many new ones, and – in our field – a new ideal of morality in art preached powerfully and verbosely by Ruskin.[42] It has been shown that in Ruskin's preaching an older English quality recurs, and much of the ideal of Dr Arnold can be traced back to earlier strata of national character.[43] Yet the years about 1850 were a new rally of all these forces – and so the England of Hogarth with its punch and its noise and the England of the Industrial Revolution with its drive and its brutality vanished – or at least vanished from the surface. For the civilizing but at the same time somewhat devitalizing changes of about 1850 were not equally effective in all classes. The dictates of court and public school were not universally obeyed by the so-called lower classes, the classes indeed which Hogarth knew, which Gainsborough

idealized, and which for Reynolds did not exist. These classes in England have kept more boisterous and in that respect more 'Continental' to this day. *The March to Finchley* is internationally more understandable than Burne-Jones's *Golden Stairs*.

Roger Fry calls the change of the mid nineteenth century 'a tragic change' towards 'Philistinism, Puritanism, and gross sentimentality'.[44] However, in his final judgement on English art as 'a minor school', a judgement quoted before,[45] he is far too much guided by this experience of the decline of painting in the last hundred years. But English art is not only art from Hogarth onwards nor is it only painting. If one includes architecture, design, and planning, and if one includes the Middle Ages, the significance of the English contribution to European art grows considerably.

England was far ahead of the rest of Europe at the time of the Venerable Bede, in illumination as well as the sculpture of the High Crosses. The art and civilization of Charlemagne's court accepted inspiration from Britain, both in learning and in art. Norman architecture in England was if not ahead certainly not behind the principal French schools, either aesthetically or structurally. In the creation of Gothic structure Royal France received its greatest stimulus, even if an indirect stimulus, from Durham. The Early English style of the thirteenth century was very different from the French High Gothic, but aesthetically at least in its best works, such as Lincoln, not inferior. English Decorated architecture of about 1300 was far more brilliant than any contemporary architecture anywhere else and English illumination of the same time at least as fine as any anywhere else. English Perpendicular architecture was an eminently original and telling creation, and it is doubtful whether any individual Gothic building of the early sixteenth century in any country is superior to King's College Chapel and Henry VII's Chapel, and Elizabethan architecture also was as original and as telling as that of France, the Netherlands, and Germany.

And so it goes on to the school of English portrait painting of

the eighteenth century, as a school not matched in any other country, to the immense international influence of Palladianism, the Picturesque garden, Robert Adam, and Wedgwood, to the equally all-embracing influence of English iron construction, to the great art of landscape painting in the early nineteenth century and its influence on France, and to William Morris, the so-called Domestic Revival of the Late Victorian decades, and the idea of the garden city. It is a contribution not to be spurned even from the most cosmopolitan standpoint.

On the strength of it, can we now venture answers to the two questions asked in the introductory chapter to this book: Is England a visual nation? Has she been visual, but is no longer? She certainly has been; of that there can no longer be any question. Is she? Once again: England has no Michelangelo, no Rembrandt, nor a Dürer or Grünewald, a Greco or Velazquez. These greatest personalities in European art all belonged to the last four hundred years, the years of the Reformation and after the Reformation, though the cases of Dürer and Rembrandt (and many others) show sufficiently that individual genius can flourish in reformed, as vigorously as in unreformed, countries. But in England it did not. That in my opinion is due to the growing importance in the national character of practical sense, of reason, and also of tolerance. What English character gained of tolerance and fair play, she lost of that fanaticism or at least that intensity which alone can bring forth the very greatest in art.

Revolutions of the imagination, we have seen, have occurred. Blake's was a fanatic one, William Morris's a more successful one, because conducted in the field of design and linked up with domestic comfort and good sense. Urban planning today is another spearhead of imagination. And there is Mr Henry Moore. So we can live in hope. But there is also the danger of timidity and inertia and of the unquestioning faith in the majority vote.

However, emotional states such as hope and danger have nothing to do with the mood in which this book was conceived and written.

NOTES AND REFERENCES

1 *The Geography of Art*

1 Quoted from Sir Eric Maclagan, *The Bayeux Tapestry* (King Penguin Books), Harmondsworth, 4th ed., 1953, p. 13.

2 Quoted from Francesca M. Wilson, *Strange Island*, London, 1955, p. 178. I had the privilege of using this intelligent, enlightening, and entertaining book in typescript and in proof. Quite a number of passages on the next pages come from it and will in every case be duly acknowledged.

3 Kindly communicated to me in a letter by Mrs Carrol Romer.

4 The speech of the Chancellor at the Opening of Parliament in 1368 was made in English.

5 See Beatrice Reynolds, in *Records of Civilization, Sources and Studies*, New York, 1945; also F. Renz in *Geschichtliche Untersuchungen*, ed. K. Lamprecht, Gotha, 1905, pp. 47–61.

6 A. H. Koller, *The Abbé Du Bos, his Advocacy of the Theory of Climate*, Champion, Illinois, 1937. Two passages are enough to show his creed: '*Il est plus que vraisemblable que le génie particulier à chaque peuple, dépend des qualités de l'air qu'ils respirent*' (*Réflexions critiques sur la poésie et sur la peinture*, Paris, edition of 1740, Part II, p. 288), and '*Voilà pourquoi . . . les Italiens seront toujours plus propres à réussir en peinture . . . que les peuples des environs de la mer Baltique*' (ibid., pp. 305–6).

7 Epistle to Thomas Villiers Lord Hyde, *Opere*, Venice, 1791–4, vol. I, p. 53. The epistle was written in 1745; see *Opere Varie*, Venice, 1757, vol. II, p. 455.

8 Quoted from Arturo Graf, *L'Anglomania . . . in Italia nel secolo XVIII*, Torino, 1911, p. 337.

9 Quoted from Miss Wilson's materials for *Strange Island*, but not used in her book.

10 Again quoted from *Strange Island*, pp. 136 and 102.

11 That does not mean that there was no reason for complaints earlier. John Evelyn (as Mrs Wainwright pointed out in a letter to me) mentions black fogs on 24 January 1684 and on 15 November 1699.

12 I was reminded of this passage by Mr J. Ferguson, *Listener*, 3 November 1955.

13 Attention was drawn to this by Mr P. Wohlfahrt in a letter to the *Listener*, 3 November 1955.

14 The protagonist among those who do not believe in the permanence or long duration of national characteristics is H. Hamilton Fyfe, *The Illusion of National Character*, London, 1940. Reference to this book was made to me in a letter by Mr N. Borg.

15 *Strange Island*, p. 187.

16 ibid., p. 207.

17 *Lettres sur les Anglais*, Basle, 1734, Letter XVIII.

18 Donald Wolfit, *First Interval*, London, 1954.

19 Quoted from, but in the end not used by, Miss Wilson.

20 *Strange Island*, p. 103.

21 *Dictionary of National Biography*, also for further literature.

22 Eric de Maré, in *Architectural Review*, vol. 120, 1956.

23 J. H. Clapham, *An Economic History of Modern Britain*, vol. I, Cambridge, 1950, p. 490. Also J. H. Clapham, *The Economic Development of France and Germany, 1815–1914*, Cambridge, 1921, L. Beck, *Geschichte des Eisens*, vol. IV, Brunswick, 1899, pp. 202 and 344.

24 For this and the following facts see L. H. Jenks, *The Migration of British Capital*, London, 1927.

25 Gogol, in his *Dead Souls*, published in 1842, mentions 'hat and candle factories, and of course foremen, appointed from London', and goes on to say that, as everybody wants to do things with complicated machinery, 'so he must travel specially to England'.

26 From *L'Œuvre de la Société Anonyme John Cockerill 1817–1947*, Liège, n.d.

27 For this and the following references to railways, C. F. Dendy Marshall, *Early British Locomotives*, London, 1939, also referring to a paper by F. Achard in vol. VII of the *Transactions of the Newcomen Society*, 1927, to A. L. Deghilage, *Origine de la locomotive*, Paris, 1866, and to C. Dollfus and E. de Geoffray, *Histoire de la locomotion terrestre*, vol. I, Paris, 1935.

28 J. G. H. Warren, *A Century of Locomotive Building by Robert Stephenson & Co.*, Newcastle, 1923, p. 321.

29 *Railway Times*, vol. III, 1840.

30 C. Hamilton Ellis, *British Railway History*, London, 1954, p. 83.

31 All these examples except that from Pastor Moritz are from *Strange Island*. They show the great usefulness of this book for the geographer of civilization. For Moritz, see *Travels in England in 1782*, Cassell's National Library, London, 1886, p. 27.

32 Quoted from *The Face is Familiar* by kind permission of J. M. Dent & Sons Ltd, London; Little, Brown & Co., New York; and Curtis Brown Ltd.

33 London, 1934.

2 *Hogarth and Observed Life*

1 John Nichols and George Steevens, *The Genuine Works of William Hogarth*, London, 1808, vol. I, p. 143.

2 ibid., pp. 97–102.

3 John Ireland and John Nichols, *Hogarth's Works*, new edition, Chatto & Windus, London, n.d., vol. III, p. 66.

4 See Ralph Edwards, *Early Conversation Pieces*, London, 1954.

5 *The Analysis of Beauty with the rejected passages from the manuscript drafts and Autobiographical Notes*, edited by Joseph Burke, Oxford, 1955, p. 202. This new and important edition was not yet available when I gave my Reith Lectures.

6 This statement (*The Analysis . . .* ed. Burke, ed. cit., p. 216) is of course historically untrue. Jan Steen is an obvious forerunner as shown by *The Effects of Temperance* (Collection P. B. Meyer Esq.) and *Light come, light go* (van Beuningen Collection). Also Mrs H. Kurz has recently drawn attention to the dependence of Hogarth's *Harlot's Progress* on a series of Italian engravings of 1655–7 called *Lo specchio al fin de la putana*, and of Hogarth's *Rake's Progress* on the Italian series *La vita del lascivo* of *c.* 1660–5 (*Journal of the Warburg and Courtauld Institutes*, vol. XV, 1952).

7 Burke, ed. cit., p. 215.

8 ibid., p. 203.

9 *Journal of the Warburg and Courtauld Institutes*, vol. II, London, 1938–9.

10 *Farington Diary*, ed. Greig, London, 1922, etc., vol. III, p. 91.

11 Roger Fry says: 'His aesthetic gift seems to be in flat contradiction to his work.' op. cit., p. 35.

12 Burke, ed. cit., p. 222. Hogarth is referring of course to Raphael's cartoons.

13 It seems more than accident in this light that the club to which the Pre-Raphaelites and their sympathizers belonged was the Hogarth Club: see e.g. W. M. Rossetti, *Dante Gabriel Rossetti*, London, 1889, p. 30, and F. M. Hueffer, *Ford Madox Brown*, London, 1896, pp. 158, etc.

14 *Lectures on Art*, 1870, Library Edition, vol. XX, p. 39.

15 *The Cestus of Aglaia*, 1865–6, Library Edition, vol. XIX, p. 49.

16 ibid., vol. XX, p. 46.

17 ibid., vol. XVIII, p. 443.

18 'A veritable debauch of trivial anecdotic picture-making' is what Roger Fry calls it (op. cit., p. 50).

19 See for instance Chaucer's *House of Fame*, III, 1186 ('Babewinnes and pinnacles, Imageries and tabernacles'). Quoted from Joan Evans, *English Art, 1307–1461* (Oxford History of English Art, vol. v), Oxford, 1949, pp. 38, etc.

20 For the Rutland Psalter see E. Millar, Roxburghe Club, 1937; for the Bible of William of Devon, see Margaret Rickert, *Painting in Britain in the Middle Ages* (Pelican History of Art), Harmondsworth, 1954, p. 101; for the Missal of Henry of Chichester, see M. R. James's *Catalogue of the Manuscripts at the Sir John Rylands Library*, Manchester, 1921, pp. 51–3. For the other manuscripts see the plates to E. Millar's *English Illuminated Manuscripts*, 2 vols., Paris and Brussels, 1926–8, and O. E. Saunders, *English Illumination*, Florence and Paris, 1928.

21 I am indebted to Dr A. Heimann for having found the two pairs of illustrations.

22 See M. D. Anderson, *Misericords* (King Penguin Books), Harmondsworth, 1954.

23 See C. J. P. Cave, *Roof Bosses in Medieval Churches*, Cambridge, 1948.

24 See Sir Eric Maclagan, *The Bayeux Tapestry* (King Penguin Books), Harmondsworth, 4th ed., 1953.

25 *Lateinische Schriftquellen zur Kunst in England, Wales und Schottland vom Jahr 901 bis zum Jahr 1307*, Munich, 1955–60, five volumes.

26 *Opus Maius* (Oxford Standard Edition), 1897–1900, vol. II, pp. 168 and 169.

27 Compare for all this the standard textbooks of medieval philosophy, notably those by Étienne Gilson.

28 For Wedgwood see E. Metyard, *The Life of Josiah Wedgwood*, London, 1865; for cast iron see John Gloag and Derek Bridgwater, *A History of Cast Iron in Architecture*, London, 1948. However, similar developments towards large-scale production are not absent in France either: see N. Pevsner in *Journal of the Royal Society of Arts*, vol. XCVII, 1948, pp. 90, etc.

29 *The Complete Works of Sir John Vanbrugh* (Nonesuch Edition), London, 1928, vol. IV, p. 29.

30 Frontispiece to vol. III of Ireland and Nichols, edition quoted above.

3 *Reynolds and Detachment*

1 Fourteenth Discourse.

2 Third Discourse.

3 Nichols & Steevens, loc. cit., vol. I, p. 297.

4 See the new edition by Robert R. Wark, Huntington Library, 1960. Also F. W. Hilles, *The Literary Career of Sir Joshua Reynolds*, Cambridge, 1936.

5 *Discourses*, ed. H. Zimmern, London, 1887, p. 14.

6 ibid., p. 30.

7 ibid., p. 16.

8 ibid., p. 80.

9 ibid., p. 26.

10 ibid., p. 6.

11 ibid., p. 40.

12 ibid., p. 54.

13 ibid., p. 59.

14 See e.g. the Introduction to Félibien's *Entretiens* of 1666.

15 *Discourses*, loc. cit., p. 86.

16 ibid., p. 38.

17 ibid., p. 268.

18 ibid., p. 56.

19 ibid., p. 56.

20 On Reynolds's Borrowings, see E. Wind in *Journal of the Warburg and Courtauld Institutes*, vols. I and II, 1938.

21 ibid., p. 48.

22 *Victorian England*, Oxford, 1936, p. 16.

23 S. T. Bindoff, *Tudor England* (Pelican Books), Harmondsworth, 1950, p. 100.

24 *Tudor Cornwall*, London, 1941.

25 Bindoff, op. cit., p. 224.

26 Quoted from G. M. Young, *Victorian England*, Oxford, 1936, p. 120.

27 W. R. Lethaby, *Philip Webb and his Work*, London, 1935, p. 94. The house was Rounton Grange, the date *c.* 1875.

28 See John Fleming in the *Cornhill Magazine*, No. 1004, 1955.

29 *Discourses*, op. cit., p. 262.

30 It must of course be understood that the choice of the costume was in all probability not Reynolds's but the family's. It may be connected with some childish theatrical performance (a suggestion put to me in a letter by Mrs Jean Hall of Broughton Hall, Staffs) of the type of the *Conquest of Mexico* acted by the children of John Conduitt in 1731 and painted by Hogarth in a familiar picture.

31 Letter of 27 April 1753, ed. Cunningham, vol. II, Edinburgh, 1906, p. 327.

32 *The Eagle*, vol. XVII, 1896. See also my comments in *Cambridgeshire* (*The Buildings of England*), Harmondsworth, 1954, p. 124.

33 Report of 1713 to the Bishop of Rochester, in Stephen Wren, *Parentalia*, London, 1750. This appreciation of conformity was in itself not a new idea of Wren nor of his age. It appeared as soon as the Renaissance had firmly established itself in Italy, in Bramante's and Leonardo da Vinci's memoranda on the completion of the Gothic Cathedral of Milan and then in the prolonged battle raging round the completion of the Gothic Church of S. Petronio at Bologna. On this see E. Panofsky, in *Staedel Jahrbuch*, vol. VI, 1930, and R. Bernheimer, in *Art Bulletin*, vol. XXXVI, 1954.

34 N. Pevsner, 'Good King James's Gothic', *Architectural Review*, vol. 107, 1950.

35 N. Pevsner, 'Double Profile', *Architectural Review*, vol. 107, 1950.

36 Exeter, Devon; Chester-le-Street, Durham; Chew Magna, Somerset; Belton, Leicestershire. Compare also the medievalizing statuary added to original Gothic statuary on the façade of a range of building at Stapleford Park in Leicestershire in 1633.

37 See K. Downes, *Hawksmoor*, London, 1959, p. 136 and pl. 41.

38 See Barbara Jones, *Follies and Grottoes*, London, 1953.

39 Duke of Norfolk portrait at Arundel Castle, Earl of Halifax portrait in the Sutton Scarsdale Sale, 1930.

40 *English Traits*, chap. VIII. More from this book will be found in pp. 201–3.

41 Quoted from Francesca Wilson's material for *Strange Island,* not included in the book.

42 *Strange Island*, p. 90.

43 ibid., p. 134.

44 Chapter XII.

45 Act III, Scene 2.

46 There are exceptions. Reynolds could communicate the fire of genius as in his *Laurence Sterne*, and reveal with vigour the character of the individual as in *Dr Johnson*. So one can perhaps say that what Reynolds refused to do was to pretend the existence of genius or pronounced individuality in sitters where there was none.

47 *The Lesser Arts, Collected Works*, vol. XXII, p. 17.

48 See note 33 above.

4 *Perpendicular England*

1 It is of course not absent, see e.g. Limburg-an-der-Hardt in Germany (*c.* 1030). The best-known French case, however, at Laon Cathedral early in the thirteenth century, is most probably one of English influence.

2 See A. W. Clapham, *English Romanesque Architecture after the Conquest*, Oxford, 1934, and T. S. R. Boase, *English Art, 1100–1216* (Oxford History of English Art), Oxford, 1953.

3 See the useful summary of German, Dutch, and Belgian excavations in *Kunstchronik*, vol. VIII, 1955, pp. 113, etc., with many diagrammatic plans.

4 See A. W. Clapham, *English Romanesque Architecture before the Conquest*, Oxford, 1930.

5 See A. R. Martin, *Franciscan Architecture in England*, Manchester, 1937; A. W. Clapham and W. Godfrey, *Some Famous Buildings and Their History*, Westminster, n.d., pp. 239, etc.; and W. A. Hinnebusch, *The Early English Friars Preachers*, Rome, 1951.

6 Sir Harold Brakspear, in *Archaeologia*, vol. LXXXI, 1931.

7 The first case, a little before 1100, is in the chancel aisles of Durham Cathedral. The extreme case is the triple-interlacing at St John's, Devizes.

8 P. Frankl, *Art Bulletin*, vol. XXXV, 1953.

9 *Reflections*, op. cit., p. 121.

10 See G. Webb in *Journal of the Warburg and Courtauld Institutes*, vol. XII, 1949.

11 My attention was drawn to this quotation by Mrs Stanton.

12 Or rather at Binham Priory in Norfolk, where the west window of the church with its tracery of the new type seems indeed to date from before 1244.

13 The French replaced the pavilion roof by the mansard roof, although Perrault's east façade of the Louvre had set the example of the flat roof with balustrade and pediment.

14 Begun in 1715 and demolished in 1822.

15 *Lettres sur les Anglais*, Basle, 1734, Letter x. He mentions Viscount Townshend's brother as a city man and Lord Oxford's younger son as a factor at Aleppo.

16 Nichols and Steevens, op. cit., vol. I, p. 300.

17 *Poetry and Prose of William Blake*, ed. G. Keynes (Nonesuch Edition), London, 1927, p. 980.

18 ibid., p. 970.

5 *Blake and the Flaming Line*

1 op. cit., p. 181.

2 These generalizations, though indispensable, simplify matters much too much. The fan-vaults in such buildings as King's College Chapel, Cambridge, are an appearance of the Decorated side of English potentialities in Perpendicular – more frequent in the last fifty years of the style than before – as the developed lierne vault with its innumerable matchstick-like ribs is an appearance of the Perpendicular side in Decorated.

3 See Georg Graf Vitzthum, *Die Pariser Miniaturmalerei von der Zeit des Heiligen Ludwig bis zu Philipp von Valois*, Leipzig, 1907, and R. Freyhan, *Die Illustrationen zum Casseler Willehalm Codex*, Frankfurt, 1927.

4 op. cit., p. 20.

5 Francis Wormald, *English Drawings of the Tenth and Eleventh Centuries*, London, 1952. Also Hanns Swarzenski, *Monuments of Romanesque Art*, London, 1954.

6 Fourteenth Discourse.

7 On Norman illumination see most recently: Margaret Rickert, *Painting in Britain: The Middle Ages* (Pelican History of Art), Harmondsworth, 1954, also the relevant chapters in T. S. R. Boase, *English Art 1100–1216* (Oxford History of English Art), Oxford, 1953.

8 This is done with some determination in Professor Frey's book, chapter I and part 8 of chapter VI.

9 op. cit., p. 23.

10 Quoted from an article by Francis Watson in *Architectural Review*, vol. 118, 1955.

11 A twentieth-century parallel to Flaxman is Eric Gill, who remains in his sculpture the sensitive and incisive wood-engraver.

12 See N. Pevsner in *Architectural Review*, vol. 113, 1953.

13 Fourteenth Discourse.

14 Robert Mylne's is an almost identical case. He also was born in Scotland, the son of an architect, had grown up in Scotland, lived for several years in Italy, and then set up in practice in London. See Christopher Gotch in *Architectural Review*, vol. 119, 1956.

15 On Scottish castles, see the splendid illustrations in Oliver Hill's *Scottish Castles*, London, 1953.

16 *Lectures on Sculpture as delivered before the President and Members of the Royal Academy*, 1829, Lecture VI (Composition). This reaction to sixth- and fifth-century Greece is paralleled by that of men such as Sir William Chambers to the Greek Doric order in architecture. See N. Pevsner and S. Lang in *Architectural Review*, vol. 104, 1948.

17 Painting and the Fine Arts, for the *Encyclopaedia Britannica*, seventh edition (1830), published at Edinburgh in 1838, pp. 213–14.

18 op. cit. (Nonesuch Edition), p. 844.

19 ibid., p. 820.

20 ibid., pp. 191–2.

21 ibid., p. 186.

22 'William Blake and the eighteenth-century Mythologists', in Ruthven Todd, *Tracks in the Snow*, London, 1946.

23 op. cit. (Nonesuch Edition), p. 580.

24 Burke, ed. cit., p. 216.

25 Roger Fry notes that Blake 'translates Michelangelo into mere line' (op. cit., p. 87). The 'mere' is typical of Roger Fry, to whom painting can only be valuable if it has a 'plastic feeling' (p. 27), 'mass and volume' (p. 46), and 'a sense of design in Depth' (p. 33).

26 Quoted from M. Schorer, New York, 1946, p. 452.

27 op. cit. (Nonesuch Edition), p. 794.

28 Letter of *c.* 1770, quoted from W. T. Whitley, *Thomas Gainsborough*, London, 1915, p. 385.

6 *Constable and the Pursuit of Nature*

1 *The Letters of John Constable, R.A., to C. R. Leslie, R.A., 1827–37*, ed. P. Leslie, London, 1931, p. 19.

2 *C. R. Leslie's Memoirs*, ed. J. Mayne, London, 1951, p. 262.

3 ibid., p. 101. Also in R. Beckett, *John Constable and the Fishers*, London, 1952, p. 125.

4 op. cit. (Nonesuch Edition), p. 103.

5 Ireland and Nichols, ed. cit., vol. I, p. 89.

6 Leslie's *Memoirs*, ed. cit., p. 179.

7 ibid., p. 15. Letter of 29 May 1802.

8 *Letters to Leslie*, ed. cit., p. 5.

9 op. cit. (Nonesuch Edition), p. 815.

10 ibid., p. 1024.

11 *Letters to Leslie*, ed. cit., p. 57.

12 Nichols and Steevens, ed. cit., vol. I, p. 390.

13 Leslie's *Memoirs*, ed. cit., p. 321.

14 The words are also Constable's, see Leslie's *Memoirs*, ed. cit., p. 322.

15 *The Connoisseur*, vol. XI, 1930, p. 186. Quoted from A. P. Oppé, *Alexander and John Robert Cozens*, London, 1952.

16 Leslie's *Memoirs*, ed. cit., p. 241.

17 Oppé, op. cit., p. 155.

18 Leslie's *Memoirs*, ed. cit., p. 286.

19 ibid.

20 R. Beckett, op. cit., pp. 81–2.

21 See K. Badt, *John Constable's Clouds*, London, 1950.

22 *Letters to Leslie*, ed. cit., p. 114.

23 T. Girtin and D. Loshak, *The Art of Thomas Girtin*, London, 1954. Quoted there from Roget's *History of the Old Water-Colour Society*, London, 1891, vol. I, p. 91.

24 Leslie's *Memoirs*, ed. cit., p. 318.

25 ibid., p. 315.

26 *Letters to Leslie*, ed. cit., p. 104.

27 R. Beckett, op. cit., p. 251.

28 ibid., p. 218.

29 ibid., p. 182.

30 *Letters to Leslie*, ed. cit., p. 104.

31 Leslie's *Memoirs*, ed. cit., p. 101.

32 ibid., p. 280.

33 R. Beckett, op. cit., p. 225.

34 Leslie's *Memoirs*, ed. cit., p. 323.

35 R. Beckett, op. cit., p. 258; 1827.

36 I have unfortunately been unable to find my own source for this saying of Hazlitt's.

37 *Letters to Leslie*, ed. cit., p. 56.

38 Leslie's *Memoirs*, ed. cit., p. 241; 1835.

39 R. Beckett, op. cit., p. 240.

40 ibid., p. 271.

41 ibid., p. 124.

42 As Geoffrey Grigson calls them.

43 G. Grigson, *Samuel Palmer*, London, 1947, p. 59.

44 ibid., p. 74.

45 ibid., p. 83.

46 Basil Taylor, *Animal Painting in England* (Pelican Books), Harmondsworth, 1955.

47 The exception to this rule is James Ward.

48 B. Taylor, op. cit., p. 30.

7 *Picturesque England*

1 Quoted from Sir William Temple by S. Switzer in his *Ichnographia Rustica*, London, 1718, vol. I, p. 53.

2 *The Analysis of Beauty*, ed. Burke, op. cit., p. 42.

3 Epistle IV, 'To Richard Boyle, Earl of Burlington, of the Use of Riches.'

4 On the Picturesque in England see Mr Christopher Hussey's masterly *The Picturesque*, London, 1927. Of more recent literature I need quote only Isobel Wakelin Urban Chase, *Horace Walpole: Gardenist*, Princeton, 1943, which sums up the present state of knowledge in some detail. I have also published several papers on the Picturesque. They came out in the *Architectural Review*, vol. 96, 1944 ('The Genesis of the Picturesque'); vol. 101, 1947 ('Chambers'); vol. 95, 1944 ('Uvedale Price'); vol. 103, 1948 ('Repton'). The paper in vol. 96 is the one most pertinent to the text of the paragraphs to which this note refers.

5 For Kent see the magnificent staircase of 44 Berkeley Square, London; Adam examples are numerous and familiar.

6 Jos. Spence, *Anecdotes*, etc., ed. of 1858, p. 196.

7 *The Guardian*, No. 173, 1713.

8 *The Elements of Architecture*, reprint, London, 1903, p. 87.

9 Quoted from my paper in *Architectural Review*, vol. 96, 1944.

10 *The Moralists, a Philosophical Rhapsody*, 1709. Quoted from the edition of 1732, vol. II, p. 394.

11 *The Spectator*, 25 June 1712.

12 Jos. Spence, *Anecdotes*, ed. cit., p. 9.

13 *The Moralists*, ed. cit., p. 394.

14 From 'Rule Britannia', in *Alfred: A Masque*, 1740.

15 *Liberty*, 1735–6, part v, lines 441, etc.

16 *A Letter from Italy*, 1701.

17 *English Traits*, chap. XVIII.

18 *Liberty*, V, lines 697–8, and 688.

19 p. 26.

20 See N. Pevsner, *London except for the Cities of London and West-minster* (*The Buildings of England*), Harmondsworth, 1952, p. 217. Also *Architectural Review*, vol. 103, 1948.

21 See S. Lang in *Architectural Review*, vol. 104, 1948.

22 Virgil, *Aeneid*, VII: 136, and in other places.

23 *Opere*, Venice, 1791–4, vol. VII, p. 81, in *Pensieri Diversi*.

24 Quoted from S. T. Bindoff, op. cit., p. 235.

25 ibid., p. 234.

26 *Lettres sur les Anglais*, Basle, 1734, Letter VI.

27 ibid., Letter XVIII.

28 See N. Pevsner, *The Cities of London and Westminster* (*The Buildings of England*), Harmondsworth, 1956, *passim*.

29 John Summerson, *John Nash*, London, 1935. See also N. Pevsner, *The Cities of London and Westminster* and *London except for the Cities of London and Westminster*.

30 See J. M. Richards, 'The Failure of the New Towns', *Architectural Review*, vol. 114, 1953, and in reply to it Lionel Brett, ibid., p. 119.

31 See features in *Architectural Review*: 'Precinct of St Paul's', vol. 97, 1945; 'St Paul's Area', vol. 100, 1946; 'Westminster Regained', vol. 102, 1947; 'Houses of Parliament', vol. 108, 1950; 'Basildon Town Centre', vol. 114, 1953; 'Midland Experiment: Ludlow, Bewdley', vol. 114, 1953; 'Evesham, Shrewsbury', vol. 115, 1954.

32 See for the Holford-Holden plan for the City of London, *Architectural Review*, vol. 97, 1945, pp. 157, etc., and *Architects' Journal*, vol. 105, 1946, pp. 43, etc. For the precincts of St Paul's, *Architectural Review*, vol. 119, 1956, pp. 294, etc., and *Architects' Journal*, vol. 123, 1956, p. 290, and vol. 124, 1956, p. 924. For the South Barbican scheme, *Architectural Review*, vol. 127, 1960, pp. 338, etc. For the Elephant and Castle scheme, *Architectural Review*, vol. 127, 1960, pp. 40, etc. For Roehampton, *Architectural Review*, vol. 126, 1959, pp. 21–35. For Stevenage, the *Town Planning Review*, vol. 31, 1960, pp. 103–6. The South Barbican plan has as its ancestor the High Barbican scheme by Sergei Kadleigh, William Whitfield, and Patrick Horsburgh (see *Architects' Journal*, vol. 120, 1954), and this in its turn was preceded by a High Paddington scheme, proposed by Sergei Kadleigh and Patrick Horsburgh and published by the *Architect and Building News*, 1952.

8 *Conclusion*

1 F. M. Wilson, op. cit., p. 48. Laziness, incidentally, to Sorbière is the fact that the English shopkeeper opens his shop only after seven in the morning, 'even in summer-time', ibid., p. 46.

2 ibid., p. 45.

3 ibid., p. 55. The week-end in the country appears as an English habit in the same book (p. 103) about the middle of the eighteenth century.

4 See the American postscript to my *Outline of European Architecture*.

5 His father's family came from Berkshire, settled in Ulster in the seventeenth and in America in the late eighteenth century; his mother's family came from Skye and settled in America in 1746.

6 See M. Rickert, *Painting in Britain: The Middle Ages* (Pelican History of Art), Harmondsworth, 1954. But in Miss Rickert's book one can also see the occasional high quality of contemporary English work – see Lydgate's Pilgrim, pl. 191.

7 He visited England in 1847–8 and published *English Traits* in 1856.

8 *English Traits* (World's Classics), Oxford, 1903, chap. XVIII, p. 176.

9 ibid., chap. III, p. 20.

10 ibid., chap. VIII, p. 83.

11 ibid., chap. III, p. 20.

12 ibid., chap. V, p. 44.

13 ibid., chap. XVII, p. 179.

14 ibid., chap. XIV, pp. 137–45.

15 ibid., chap. V, p. 48.

16 ibid., chap. IV, p. 47.

17 ibid., chap. VI, p. 65.

18 ibid., chap. III, p. 227.

19 ibid., chap. XVIII, p. 180.

20 ibid., chap. VI, p. 62.

21 ibid., chap. XIII, p. 131.

22 ibid., p. 130.

23 ibid., p. 135.

24 ibid., chap. IV, p. 41.

25 ibid., p. 46.

26 ibid., p. 26.

27 ibid., chap. V, p. 58, and chap. X, p. 90.

28 ibid., chap. XI, p. 111.

29 ibid., chap. XII, p. 123.

30 ibid., chap. X, p. 93.

31 ibid., chap. VI, p. 61.

32 ibid., chap. VII, p. 69.

33 ibid., chap. VIII, p. 75.

34 ibid., chap. IX, p. 88.

35 ibid., chap. IV, p. 37.

36 *Studies in Social History* (the G. M. Trevelyan *Festschrift*), Cambridge, 1955.

37 Leon Radzinovicz, *A History of English Criminal Law and its Administration from 1750*, vol. I, London, 1948, p. 14.

38 J. L. and B. Hammond, *Lord Shaftesbury* (Pelican Books), Harmondsworth, 1939, p. 212, and on other pages.

39 Quoted from G. L. Prestige, *St Paul's in its Glory, 1831–1911*, London, 1955.

40 John Summerson, *John Nash*, London, 1935, *passim*.

41 *Victorian England*, Oxford, 1936.

42 The case of public schools is specially illuminating. In looking through school histories one is time and again struck by the advent of a 'second founder' in the mid nineteenth century, such as Ridding at Winchester, Pears at Repton, and so on. In J. Sargeaunt's *Annals of Westminster School* (London, 1898) the chapter on 1819–46 is called 'Decline', the chapter starting with Liddell's coming in 1846 'Revival'. At Harrow there were 69 boys when Dr Vaughan started in 1844, but 315 in 1847. At Tonbridge the corresponding figures are 43 for 1843, 235 for 1875; at Sedbergh 38 for 1838, 85 for 1878, 155 for 1888; at Dulwich the change came after 1857, at St Paul's after the move to the new building in 1877. Of the *c.* 190 boys' schools now in the Headmasters' Conference, 18 were founded before the sixteenth century, 67 in the sixteenth century, only 20 in the seventeenth, only 7 in the eighteenth, but 78 in the nineteenth and after. Cheltenham was started in 1841, Marlborough in 1843, Rossall in 1844, Brighton in 1845, Radley in 1847, Lancing in 1848, Hurstpierpoint in 1849, Leatherhead in 1851, Epsom in 1853, Wellington in 1856, Beaumont in 1861, Clifton in 1862, Cranleigh in 1863, Malvern in 1865, Eastbourne in 1867, Bishop's Stortford in 1868. That makes sixteen in twenty-eight years.

43 Emerson quotes this from Fuller's *Worthies*. It refers to Baron Vere: 'Had one seen him returning from a victory, he would have by his silence suspected that he had lost the day; and had he beheld him in retreat, he would have considered him a conqueror by the cheerfulness of his spirit.'

44 op. cit., p. 90.

45 ibid., p. 23.

INDEX

All references in roman type *are to page numbers of the text; those in* italic type *are to illustration numbers.*

More About Penguins and Pelicans

Penguinews, which appears every month, contains details of all the new books issued by Penguins as they are published. It is supplemented by our stocklist, which includes around 5,000 titles.

A specimen copy of *Penguinews* will be sent to you free on request. Please write to Dept EP, Penguin Books Ltd, Harmondsworth, Middlesex, for your copy.

In the U.S.A.: For a complete list of books available from Penguins in the United States write to Dept CS, Penguin Books, 625 Madison Avenue, New York, New York 10022.

In Canada: For a complete list of books available from Penguins in Canada write to Penguin Books Canada Ltd, 2801 John Street, Markham, Ontario L3R 1B4.

Also by Nikolaus Pevsner

An Outline of European Architecture

This seventh revised edition of Nikolaus Pevsner's classic
history is presented in an entirely new and attractive
style. The format has been enlarged and the illustrations
appear next to the passages to which they refer. Their
numbers have swelled to nearly 300, including drawings,
plans, and photographs. The final chapter of the Penguin
Jubilee edition has been incorporated, carrying the story
from 1914 to the present day, and there are substantial
additions on the sixteenth to eighteenth centuries in
France as well as many minor revisions. The book tells
the story of architecture by concentrating on outstanding
buildings, and reads exceedingly well in its concentration
and its combination of warmth and scholarship.

A Pelican Book